MANET

MANET

John Richardson

with notes by Kathleen Adler

Phaidon Press Limited
Regent's Wharf, All Saints Street, London, N1 9PA

Phaidon Press Inc.
180 Varick Street, New York, NY 10014

www.phaidon.com

Introductory essay published 1958
This edition first published 1982
Reprinted 1989, 1992, 1993, 1994, 2002, 2003
© 1958, 1982 Phaidon Press Limited

ISBN 0 7148 2755 X

A CIP catalogue record for this book is available from the
British Library

Printed in Singapore

The authors and publishers would like to thank all those museum
authorities and private owners who have kindly allowed works in
their possession to be reproduced. Particular thanks are due for the
following: Plates 5, 15 and Figs. 22, 26, which are reproduced by
courtesy of the Trustees of the National Gallery, London; Plate 47,
which is reproduced by permission of the National Gallery of
Victoria, Melbourne.

Cover illustrations:
(front) *The Waitress*. (Plate 38)
(back) *Soldier*. (Plate 15)

Manet

Clarity, candour, urbanity and a virtuoso ability to handle paint – such are the qualities which first strike us in Manet's art. Here, we feel, is an *oeuvre* which raises no aesthetic problems and demands no special knowledge, which can be enjoyed effortlessly, for its own sake and on its own merits. And yet how wrong our first impressions are! For underneath its bland surface Manet's art abounds in pitfalls and contradictions, so much so that none of the writers who have tried to analyse it agree on the master's special qualities or failings, and his rightful place in the hierarchy of the great is still disputed. At various times, Edouard Manet has been described as a 'frightful realist' (Gautier) and as someone 'unfortunately marked by romanticism from birth' (Baudelaire); as 'a great painter for whom Impressionism was a deplorable aberration' (Roger Fry); as 'the most astonishing virtuoso of the modern school' (Colin) and as 'uninspired', 'mediocre' and 'mechanical' (Zervos); as a 'prince of visionaries' (Paul Mantz) and as 'totally without imagination' (Florisoone and others); as 'a revolutionary to end all revolutionaries' (Cochin), but also as 'nothing of a revolutionary, not even a rebel' (Colin) and as a '*sale bourgeois*', 'consumed by a vulgar ambition for "honours"' (Clive Bell). Now, although some of these opinions are patently ridiculous, many undeniably contain a modicum of truth.

The task of reconciling the various anomalies and of distinguishing a coherent pattern in Manet's development is far from easy. It becomes possible, however, if we realise that the there is a deep-seated dichotomy in Manet's character and that the artist, like the man, has more than a single face: he was both a devoted domesticated husband as well as an impenitent *coureur*; a pious Catholic as well as a sceptical humanist; a gullible innocent as well as a cunning schemer; an ardent Socialist as well as a conforming bourgeois; a hard-working artist as well as an elegant *flâneur* 'who adored the *monde* and derived a secret thrill from the brilliant and scented delights of evening parties' (Zola). This does not mean that Manet was a hypocrite. He was intellectually too honest. Nor was he a schizophrenic, since his personality, though protean, was well integrated.

True, Manet aspired to be an officially recognised master like Ingres. He was proud of tracing his artistic lineage back to Giorgione and Titian, though no further – earlier European art was 'barbarous'. He was also one of the last great artists to work in terms of individual set-pieces rather than in series of variations on a given theme (like Degas, Monet and the Impressionists); and by the same token he persisted, unlike other independent artists, in submitting his works to official exhibitions, because, as he said, 'the Salon is the real field of battle. It is there that one must take one's measure'. To this extent he conformed to the pattern of the past. And yet Manet loathed academicism, partly because it falsified the image in the mirror which, he felt, art ought to hold up to contemporary life; and partly because he felt that

Fig. 1
Edouard Manet
c.1865. Photograph by
Nadar. Bibliothèque
Nationale, Paris

the tradition of the old masters had ceased to be valid and that a new style based on a synthesis of old and new elements was needed. He succeeded because, like most of the greatest modern innovators – Monet, Van Gogh, Cézanne, Matisse, Picasso and Braque – he was primarily an artist, not a theorist with preconceived notions of ideal beauty. In art the best results are achieved by intuitive rather than intellectual processes. Moreover, the synthesis of opposites which was at the root of his character helped Manet to fuse seemingly irreconcilable elements – taken from Daumier, the Spanish and Venetian masters, contemporary photographs and engravings, Frans Hals, Japanese wood-engravings and many other sources – into a viable modern style. It is thus a mistake to see Manet as 'the last of a race'. But is he 'the first of the moderns'? Here we must be careful to do full justice to Courbet, who was among the first to see that not only morally elevating subjects taken from history, legend or religion, but anything, no matter how humble and ordinary, is worthy of an artist's attention. This was to revolutionize the artist's approach to subject-matter, just as Manet's discoveries were to revolutionize the artist's approach to style. We should try to see Manet and Courbet together as twin begetters of the modern movement.

Manet's duality of temperament accounts for all kinds of paradoxes in his life, for instance a statement which he made in 1867 apropos an exhibition of some of his most controversial works: 'M. Manet has never wanted to make a protest . . . He claims neither to have overthrown the art of the past nor to have created a new order'. This, however, is exactly what he had done, but it would be a mistake to conclude that these words were insincere or disingenuous. They were dictated by the conformist side of his nature, by that side which aspired to official recognition and which – fortunately for his art – never managed to prevail. Not that Manet's conformist side was as black as it has been painted; the legend of the *sale bourgeois* who failed to live up to the genius thrust upon him by fate, dies hard. Far from being 'consumed by a vulgar ambition for "honours" . . . and praise', Manet could not bring himself to give his art a different look or make the concessions which officialdom expected of him. It is also too easily forgotten that Manet was an exceptionally cultivated and sensitive man with a profound knowledge of literature and music – is it not significant that he was the intimate friend of two of the greatest poets (Baudelaire and Mallarmé) of the century? – and that he came from one of those austerely high-minded and pious families which traditionally provided the French State with the most eminent of its public servants? From his father, a distinguished jurist, and his mother, an amateur musician, Manet inherited his judicial detachment, his sure taste, his moral courage, his sharp intelligence and the toughness of spirit that sustained him through eight years of intense training and throughout his subsequent struggles. He also inherited from his parents a desire for conventional success, though there was nothing opportunist or self-seeking about this.

So much for Manet the conformist: now for the rebel. The fact that the artist was all his life a convinced left-wing Republican, a bitter enemy of the Second Empire and a firm friend of men like Gambetta, Jules Ferry and Zola, is usually passed over in silence. No doubt, the treatment meted out to Manet by the Emperor's artistic advisers strengthened his views; on the other hand, we must remember that, at the age of 16, he was already inveighing against the prospect of Napoleon's election and that he was deeply affected, as a youth, by the Revolutions of 1848 and 1851 – events which he experienced at first hand and even depicted. Because he disliked parading his private feel-

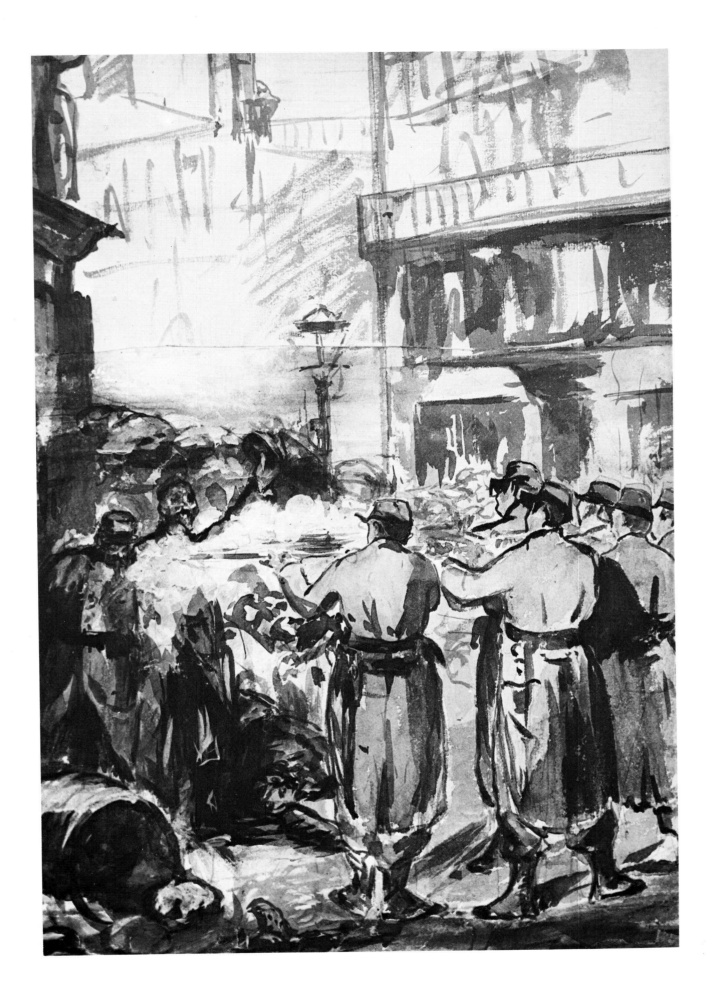

7

ings, Manet's work seldom reflects his political convictions. There are, however, certain paintings which we cannot fully appreciate without taking them into consideration: notably *The Execution of the Emperor Maximilian of Mexico* (Plate 14).

Manet never made any secret of his political sympathies, so it is not surprising that during the Commune – like Corot, Courbet and Daumier – he was elected to the *Fédération des Artistes de Paris*. True, this occurred while Manet was absent from Paris and when he returned, during the last days of the Commune, he held aloof from the organization, because he was out of sympathy with extremist elements; however, a few drawings and lithographs of barricade scenes in a less detached vein than usual bear witness to his horror at the atrocities committed by the advancing army (Fig. 2). After the Commune, Manet had hopes of expressing his liberal feelings in portraits of Victor Hugo and of his friend and hero Gambetta speaking in the Chambre des Députés, but the statesman was too busy to spare more than two sittings – both unproductive – and Manet complained to Proust that, although Gambetta was more advanced than most, Republicans were reactionaries when it came to art. With Henri Rochefort – the *communard* journalist who made a sensational escape by boat from a penal colony – Manet had better luck: he persuaded him to sit for his portrait (Plate 43) and painted two pictures celebrating his exploit. That Manet should make a hero of this notorious revolutionary was shocking enough; that he should then submit his portrait to the Salon of 1881 struck his friends as the act of a madman, since it nearly lost him the Salon medal and *Légion d'Honneur*, which he had always coveted. But it is characteristic of Manet that he did not play for safety in politics any more than in art.

Like his political opinions, Manet's revolutionary approach to art declared itself at an early date. He is said to have loathed school; even drawing-lessons, arranged by his kindly Uncle Fournier, bored him so much that he took to making caricatures instead of studies after plaster-casts and had to be expelled from the class. History paintings, which Manet was expected to copy, struck him as absurd anachronisms and, while still at school, the boy announced that Diderot was talking nonsense when he maintained that an artist should not paint a man in contemporary dress: 'One must be of one's time,' said Manet, 'and paint what one sees'. Already in youth, he showed considerable strength of character. When his formidable father tried to force him to follow a legal career, he insisted on becoming a naval cadet and when, in 1850, he failed his naval exams, he persuaded his father to allow him to study art under Couture. The best description of Manet at this period is by Antonin Proust, a fellow-pupil in the same studio and the artist's lifelong friend. Manet, he says, was of 'medium height and muscular build. He had a lithe charm which was enhanced by the elegant swagger of his walk. No matter how much he exaggerated his gait or affected the drawl of a Parisian urchin, he was never in the least vulgar. One was conscious of his breeding . . .'.

Manet's relationship with Couture is something of a mystery. Certainly it was uncomfortable, but it is difficult to believe that Manet had as much contempt for his master as he later claimed. For he not only studied under Couture for six years, but ended by developing a style based on that of his master, as for instance in the early *Portrait of Antonin Proust* (Private Collection) and in *The Boy with the Cherries* (Gulbenkian Foundation, Lisbon), a pastiche that recalls, among much else, the study of a boy painted by Couture in 1846. The trouble was that Couture, who is too seldom given credit for his many liberal and anti-academic ideas, had an unreasoning hatred of realism, as witness

his satirical painting of a student drawing a pig's snout (*The Realist*, Crawford Municipal School of Art, Cork). Now Manet, who admired his master up to a point, sincerely believed that Couture would eventually come round to accepting the realist vision, and it was not until 1859, when he submitted *The Absinthe Drinker* (Plate 1), his first truly realist painting, for Couture's approval that he suddenly realised his great mistake. 'There is only one absinthe drinker here', was Couture's comment, 'the painter who perpetrated this madness.'

The Absinthe Drinker was both the cause of Manet's final rift with Couture and the occasion of his first brush with officialdom, for it was rejected by the Salon jury in 1859. This was a further blow to Manet, who made up his mind to choose a less controversial subject for the next exhibition. In the winter of 1860-1 Manet embarked on a large composition of a nude in a landscape (there is a preliminary sketch in the National Gallery, Oslo) based on an engraving by Vorsterman after Rubens. Although apparently destined for the Salon, this canvas did not in the end please the artist, who abandoned it and sent instead two paintings which he had completed earlier in the year: the portrait of his parents and *The Spanish Singer* (Metropolitan Museum of Art, New York). To Manet's great delight, both paintings were accepted by the jury, *The Spanish Singer* was awarded a medal (2nd class) and it was sufficiently well received by the critics for the artist to imagine that he had begun to make his reputation.

Surprisingly, no critic seems to have detected Manet's one stylistic innovation – the elimination of half-tones – which justifies us in regarding *The Spanish Singer*, and, to a lesser extent, the double portrait as sign-posts for the future development of nineteenth-century art. Instead of being steeped in the ochreous, old-masterish – or, as Manet called it, 'gravy-like' – penumbra common to most Salon exhibits, the onion-eating, wine-swigging guitarist is bathed in a harsh, flat light which makes him startlingly real. By exploding the fallacy of half-tones keyed to a *nuance dominante*, Manet established the artist's right to paint in whatever colours or tonalities he liked and thus enormously facilitated the development of Impressionism and much subsequent art. Small wonder that by the end of 1861 Manet found himself surrounded by a small but enthusiastic band of young artists – Legros, Carolus-Duran and Fantin-Latour among others – who looked up to him as a new master!

1862 is a crucial year for Manet's development. In a bid to consolidate his success of 1861, the thirty-year-old artist embarked on a series of ambitious paintings. According to Tabarant, the first of these is the large *The Old Musician* (Plate 3), a set-piece inspired by Velázquez' *Topers*, which Manet had not yet seen but which he knew at second hand from Goya's engraving. Despite the rich, fresh beauty of its paint, *The Old Musician* is not altogether successful, for it is evidently pieced together out of separate studies. There seems to be no spatial, temporal or compositional, let alone thematic, relationship between the figures. These faults recur on many of Manet's works of the 1860s, and for a reason that is not hard to find: Manet's sense of design was faulty. Now instead of disguising this weakness, as a less independent artist might have done, by making judicious use of the compositional formulae taught in art schools, Manet repeatedly drew attention to it by dispensing with all but the most summary indications of perspective and by trying to reproduce on his canvas the informal – or, as he called them, 'naïve' – groupings of everyday life. This was courageous, but a number of his figure-compositions – especially those, like *The Old Musician*, consisting of a row of casually placed figures – disintegrate. As a result, the spatial illusion is often flawed by a further habitual

weakness, an erratic sense of scale: e.g. the disproportionate woman in the background of *The Picnic* (*Le Déjeuner sur l'Herbe*, Plate 6), the minuscule boy in the foreground of *View of the International Exhibition* (National Gallery, Oslo) and the gigantic man with the sunshade in *Beach at Boulogne* (Plate 20). True, Manet was a tremendously spontaneous painter who 'hurled himself on his bare canvas in a rush, as if he had never painted before' (Mallarmé); hence the freshness and unlaboured virtuosity of so many passages in his paintings, hence the clumsiness and shortcomings of others. But even when he took the precaution of making preliminary sketches, he was apt to end up with poorly articulated design, especially if the composition involves a degree of recession or includes two or more isolated figures or groups.

Further examples of Manet's compositional difficulties are easily found, but this discussion of them may well end with a look at a large figure painting, of a Spanish subject and of 1862. The composition of *Lola de Valence* (Plate 4) is wholly successful; the pose, of course, derives from Goya and the setting has been taken over from a Daumier lithograph (*Dire . . . que mon temps, moi aussi, j'ai été une brilliante Espagnole...*) of 1857; but the different elements are perfectly adjusted and the scenery is cleverly used to enhance the back-stage reality as opposed to the romantic illusionism of the theatre.

Manet, the reader must by now have gathered, was a fervent Hispanophile and, in this respect, typical of his period. *Hispagnolisme* – the fashion for things Spanish – had started with Romantic poets and writers like Gautier, Mérimée and Hugo, and by the end of the 1830s had become a popular craze. By 1848, however, it was waning and might soon have died out if, in 1853, the Emperor had not married a Spanish beauty and thereby given it a new lease of life. Such facts as these are not irrelevant, for Manet was inordinately sensitive to fluctuations in fashion. But at the same time we must reckon with the possibility – or, to my mind, the probability – that Manet's *Hispagnolisme* also had its origins in a first-hand experience of Spanish art.

Fig. 3
The Little Cavaliers
1860-1. Etching and watercolour

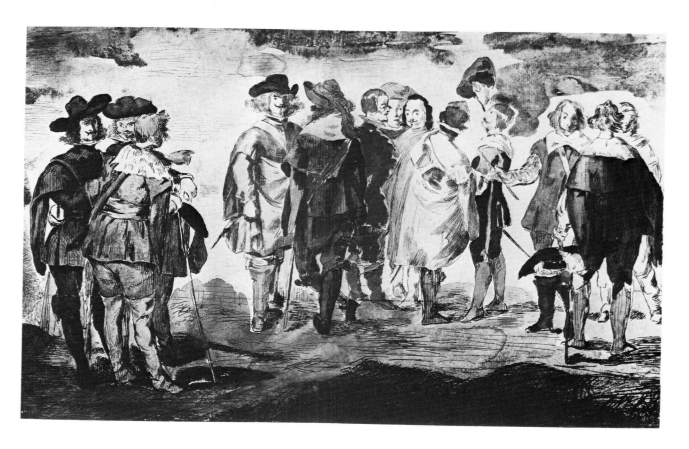

The few works surviving from Manet's student days are mostly copies after the old masters, so we cannot be sure when the Spanish influence first manifested itself. Certain it is, however, that at the end of the 1850s, when the artist was breaking with Couture, he turned to Goya and Velázquez for help in the formation of his new style. Now it is not altogether a coincidence that Spanish mannerisms appear so frequently in Manet's art at this time, for in 1859 a series of Goya's engravings was published which greatly impressed Baudelaire and his friends, Manet among them. Partly under the influence of these, Manet painted *The Spanish Singer* and a number of engravings in a Goyaesque manner. I also suspect that the sharp contrasts of white and black, which he so much admired in Goya's graphic work, proved helpful to Manet in ridding his palette of half-tones. Velázquez was less easy to study in the Paris of 1860; nevertheless, Manet made paintings, drawings and engravings after various works then labelled Velázquez in the Louvre, notably the *Portrait of the Infanta Margareta* and *The Little Cavaliers* (Fig. 3). At the same time he also painted two *Hommages à Velázquez*, imaginary scenes depicting the Spanish master and his models; and when in 1862 the Louvre purchased a *Portrait* of Philip IV Manet did a drawing and an engraving after it.

Manet's style, as well as his subject-matter, was deeply influenced by *Hispagnolisme*, especially by the various Spanish performers whom he saw at theatres and music halls in the early 1860s. In the same way, when a *cartel* of bull-fighters arrived in Paris in 1863, Manet made a point of getting them to come to his studio. The result is The '*Posada*', a group of toreadors in a tavern preparing for a bull-fight. Once again, as in *The Little Cavaliers*, the figures – more than a dozen of them – are disposed in a frieze-like manner, and once again the composition does not altogether cohere, although this gives it a certain life-like awkwardness.

Manet's *Hispagnolisme* has been examined at some length, because it was largely responsible for transforming him from a brilliant student into a mature and original artist. By soaking himself in the work of the Spanish masters, Manet learnt how to condense and simplify his pictorial effects, how to produce natural groupings and attitudes, how to use blacks and greys as active colours and how to apply paint in a rich, loose and liquid manner far removed from the dry and costive *touche* advocated by Couture. And by learning how to paint Spanish subjects from life without relying on picturesque, romantic or exotic effects, Manet developed the straightforward, detached approach of the 'Peintre de la vie moderne', a role in which he made some of his most impressive artistic contributions in the early 1860s and particularly in the late 1870s (Fig. 4).

When Baudelaire evolved the conception of the 'Peintre de la vie moderne' – the artist who would 'extract from fashion whatever poetry it might contain' and separate 'the eternal from the transitory' – he had Constantin Guys in mind. But his famous article applies just as well to Manet who was already a close friend of the poet's before 1860. Baudelaire defined 'the painter of modern life' as a dandy, a stroller who mixes with the crowd, watches the world go by, is in the midst of things and yet, as a personality, remains hidden. He envisaged a man with a natural curiosity about life who was anxious to appreciate everything going on around him, but content to stand on the periphery and remain impartial. Is this not precisely what Manet aspired to be? It is certainly an exact description of his attitude, when in 1862 he executed his first great scene of contemporary life, *Music in the Tuileries Gardens* (Plate 5) – a picture of prime importance for the development not only of Manet's *oeuvre* but of modern French art. True, as has frequently

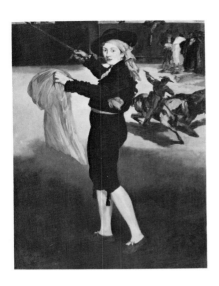

Fig. 4
Mlle Victorine in the
Costume of an Espada
1862. Oil on canvas.
Metropolitan Museum
of Art, New York

been pointed out, it is derivative in composition, for it recalls eighteenth-century *études de moeurs* by Saint-Aubin and Debucourt and also has affinities with a lithograph by Daumier and with scenes of Parisian life by Guys and other draughtsmen who worked for illustrated papers. But in every other respect, it is original: it is the first out-of-doors scene (as opposed to a straightforward nature study) which is entirely convincing as such: it is the first important French painting to sacrifice 'finish' and 'detail' to the general impression of an animated scene; it is the first record of nineteenth-century bourgeois life that is detached, realistic and seemingly spontaneous while yet being a work of art; indeed, it has quite a claim to be the first truly modern picture, at any rate in Baudelaire's sense of the word 'modern'. Here we find none of the prettification or fashion-plate triviality which detract from comparable subjects by Isabel or Lami, nor – at the other extreme – the studio stuffiness or heavy-handed social comment which sometimes mar Courbet's realistic evocation of rural life. *Music in the Tuileries Gardens* celebrates no particular incident. It is a literal record of everyday life, and it was this fact which provoked an uproar when it was exhibited. The 'slapdash' manner of its execution was bad enough, but what most irritated the Parisians was to see themselves depicted informally, as they really were.

For much the same reasons the public attacked Manet's other key picture of 1862, *The Street Singer* (Plate 2), which depicts a drab-looking Parisian street singer emerging from a low tavern. Had there been a touch of pathos in the treatment of the subject, the public might have overlooked its ordinariness. But there is nothing sentimental or anecdotal about it; worse, as Paul Mantz pointed out, 'there is nothing more here than the shattering discord of chalky tones with black ones. The effect is pallid, harsh, ominous'. Manet's abandonment of half-tones was of course partly to blame for this 'shattering discord', but we must also consider another element which creeps into his style at this time: the influence of Japanese prints. Look, for instance, at the way the street singer is reduced to a sort of bell-shaped cut-out, her dress being treated as an almost two-dimensional surface on which trimmings and folds form a bold, linear pattern, as in an Utamaro or a Hokusai. In *The Street Singer* the *japonnerie* is still rudimentary, but in subsequent works – *Olympia* (Plate 7) and *The Fifer* (Plate 13), for example – it becomes a dominant stylistic ingredient. However, Manet always makes such discreet use of *japonnerie*, blending it with elements from Spanish and Venetian art and even from *images d'Epinal*, that one seldom realizes what an active role it plays. For instance, at first sight, the *Portrait of Emile Zola* (Plate 16) seems to owe its conception to Venetian art; and yet, when closely studied, this canvas proves to be based on a decorative arrangement of flattened, vari-coloured forms such as one sees in the print by Utamaro in the background. Definite traces of Japanese influence are likewise to be found in the treatment of the negress and the setting of *Olympia*, in the right-hand figure in *The Balcony* (Plate 18), in *The Woman with the Fans* (Fig. 5) and in many later pictures.

Manet was not the first nineteenth-century painter, of course, to discover or to exploit the stylistic possibilities of Japanese art. On the contrary, *japonnerie* had been in fashion with a restricted *avant-garde* circle since the mid-1850s when Félix Bracquemond (the engraver), the Goncourts and, a little later, Baudelaire had started to popularise Japanese wood-engravings. When Manet was forming his style, *japonnerie*, like *Hispagnolisme*, was in the air. Through studying Japanese prints, Manet learnt how to flatten his forms, how to simply his spatial notation, how to dispense with a perspectival continuum, how to arrive

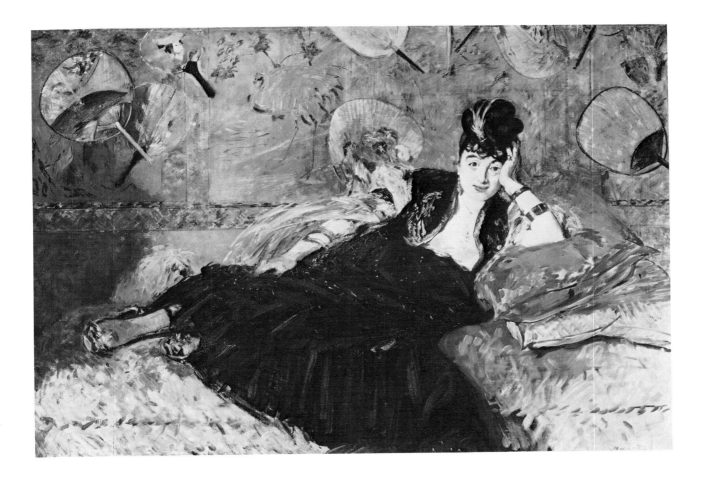

Fig. 5
The Woman with the
Fans (Nina de Callias)
c.1881. Oil on canvas.
Musée d'Orsay, Paris

at a rhythmic, linear structure and how to give his 'naïve' compositions a measure of decorative unity. Manet's imaginative exploitation of *japonnerie* is of the utmost importance for the subsequent development of nineteenth-century art, for it revealed to Degas, the Impressionists and post-Impressionists (notably Gauguin, Toulouse-Lautrec and Van Gogh) a convenient escape route from the academic *impasse* in which European art was trapped.

Japonnerie and *Hispagnolisme* were not the only mid-century phenomena to influence Manet's style; the camera also plays an important role. Here again Manet gives evidence of his perception and originality. Most artists of the period, as Baudelaire complained, were trying to pit their puny resources against the new invention by attempting to produce pictures as accurate and detailed as photographs. On the other hand, Manet, himself an expert amateur photographer, realised that there was no call for the artist to sell out to Daguerre, because the camera obviated the need for excessive representationalism. Moreover he saw that he could learn a great deal from the way in which the impartial eye of the camera recorded things as they really were, and in sharp contrasts of black and white. Like Degas, Manet occasionally worked from photographs; and he may also have made some use of photographs when working on likenesses of various friends and celebrities in *Music in the Tuileries Gardens*. But the most significant, at the same time most elusive, manifestation of the camera's influence on Manet's vision is to be found in the frozen, naturalistic poses and 'deadpan' expressions – so redolent of the photographer's studio – which are characteristic of virtually all his portraits and figure-paintings done before 1870: for example those in *The Picnic* (Plate 6) and *Luncheon in the Studio* (plate 19). What are those models staring at so intently, yet so vacantly? Not the artist, one feels, but Nadar's 'magic box'. And why this mask-like impassivity? Here Manet's Baudelairean cult of

dandyism provides the answer. A dispassionate approach allowed Manet to capture 'the character of a dandy's beauty', which according to Baudelaire, 'lies in the coldness of the gaze, the outward expression of an unshakeable resolution not to moved. One could compare it to a dormant fire whose existence we can only guess at, for it refuses to burst into flame. This [Baudelaire was actually referring to Guys, but these words are most applicable to Manet] is what these pictures express to perfection'.

By the end of 1862 Manet had every reason to feel satisfied: in one year he had completed over a dozen major and numerous minor works, had managed to transform his hesitant manner into a strong, supple and personal style and, no less important, had discovered how to express on canvas the life of his native city and of his own time. Not unnaturally he was eager to exhibit what he had done as soon as possible, so as to prove that he was no longer a promising beginner; consequently fourteen of his best paintings were put on show at the Galerie Martinet at the beginning of March 1863. Manet hoped that they would enjoy such popular success that the Salon jurors would unhesitatingly accept three others which he proposed to submit to them later in the spring. But his optimism was as usual misplaced and his one-man show – an innovation to which the public was not as yet accustomed – was received with vituperative abuse by all but a minority of critics and a few young painters (Monet and Bazille among them). One visitor even threatened to attack *Music in the Tuileries Gardens* with his walking-stick. Worse was to come; Manet's three Salon entries – *Young Man in the Costume of a 'Mayo'*, the *Mlle Victorine in the Costume of an Espada* (Fig. 4) and *The Picnic* – were rejected. With good reason Manet protested; nor was he the only artist to do so. More than 4,000 works were refused by the Salon jury that year, including paintings by Cézanne, Whistler, Pissarro, Fantin-Latour and Jongkind, and the ensuing complaints were so loud and numerous that the Emperor was forced to take notice of them. More out of a desire to prove the Salon jury right than out of any desire to display his own liberal feelings, the Emperor decreed that all the rejected pictures should be exhibited together in the Palais de l'Industrie. Manet, who seldom despaired for long, welcomed this opportunity of displaying his work, but once again his hopes were to be shattered. The public and critics (except for Zacharie Astruc and Thoré-Bürger) were in no mood to be lenient to the *Salon des Refusés*, as the exhibition came to be known; and while they jeered at everything, they singled out Manet's work, especially *The Picnic*, for their scorn.

Little is to be gained by quoting at length from the journalistic attacks on Manet beyond the insight which they afford into the depths of Second Empire philistinism. For Manet's persecutors were on the whole ill-informed and obtuse, and their invective casts darkness rather than light on his achievements. So far as one can see, what most shocked people about *The Picnic* was that it treated a *risqué* subject seriously. Had Manet presented his picnic as a titillating *scène galante*, had he treated it in an idyllic or pastoral instead of a modern manner, or had he dressed up the men in doublet and hose and given his composition a high-falutin' poetic title, the public might have been less incensed. What they could not stomach was the naturalism of the conception, the absence of anecdotal detail and sentiment, and the fact that the light, instead of being conventionally golden, is clear, cool and shines equally on the whole scene instead of being used to pick out pretty passages.

Had Manet really been (as Paul Colin and others have maintained) a cowardly traditionalist, he would presumably have heeded his critics

and adjusted his style. But much as he longed for recognition and popularity at this time, Manet made no concession to bourgeois taste and continued in a more, rather than a less, revolutionary way. After finishing *The Picnic*, he embarked on *Olympia* (Plate 7), the work which the artist always considered as his masterpiece. And rightly so, for it is a triumphant proof of the power and originality of the style which Manet had arrived at by a laborious process of synthesis, a style which anticipates much of the best twentieth-century art in being based on conceptual rather than perceptual elements. *Olympia* is a tremendous advance on *The Picnic* painted only a few months before. Forms are more ruthlessly flattened and simplified and the main motif of the picture – the figure, the bed, the bouquet and the maid (or rather her dress) – is restricted to a lightly modelled, lightly coloured mass silhouetted against a dark background. And yet, despite its seeming flatness, *Olympia* evokes a sensation of volume, thanks to a few cunningly placed shadows, to the subtle suggestion of an outline (one of Manet's most criticised innovations, and yet what could be more orthodoxly classical?) and to the heavy impasto of cream-coloured paint, which gives to the girl's body a marvellous tactile quality and fleshy density. *Olympia* has become so hackneyed that its beauties are difficult to appreciate today but, to my mind, no amount of reproductions can stale its radiance or its freshness.

What did Manet think would happen when he exhibited *Olympia* at the Salon of 1865? Admittedly he was somewhat naïve, but still he cannot have been so naïve as to imagine that the style and subject of his latest picture were anything but provocative. 'A yellow-bellied courtesan', *Olympia* was called, ' a female gorilla made of india-rubber outlined in black'. Even Courbet, hitherto a partisan of Manet's, is said to have compared her to 'the Queen of Spades after her bath'. When words failed, physical attacks were made on the picture, which was only saved by being hung out of reach above a door in the last gallery, 'where you scarcely knew whether you were looking at a parcel of nude flesh or a bundle of laundry'. Nevertheless, as Paul de Saint-Victor wrote, 'the mob continued to crowd round Manet's gamey *Olympia* and disgusting *Ecce Homo* as if they were at the morgue'.

As with *The Picnic*, it was not only the stylistic innovations of *Olympia* which infuriated people, but the 'shamelessness', 'immorality' and 'vulgarity' of the subject. Here was a naked girl, whom anybody could recognise (one of the few nudes in art of which this can be said), not an anonymous nude masquerading as a Circassian slave, coquettish Bathsheba, simpering nymph or frigid, ideal beauty. *Olympia* reclines – appropriately enough – on a bed and receives from her black maid a bouquet, a tribute to her charms. Now the salon public was partial to *risqué* subjects, so long as the real action was disguised by some polite convention, that is to say dressed up as allegory or presented as a castigation of sin. Manet, however, was too much of a dandy to dissemble or moralize, and his *demi-mondaine* is portrayed with characteristic detachment – naked, unabashed (the critics of course said 'brazen') and unmistakeably a Parisienne of her time; just the sort of Parisienne, indeed, that many a Salon visitor kept hidden from his wife. All this so scandalized people that by the time the Salon closed Manet's notoriety, said Degas, had become 'as great as Garibaldi's'; in fact, it had attained such proportions that instead of 'enjoying the arrogant satisfaction of not being astonished', Manet discovered that he had become the unenviable butt of public ridicule. At this point he lost confidence and found himself unable to go on painting, and fled to Spain.

Manet's visit to Spain was both a revelation and a disappointment: a revelation because the Spanish masters exceeded his highest hopes

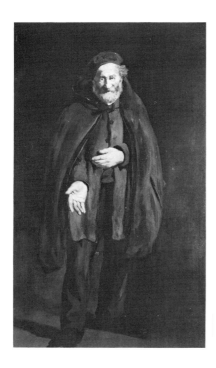

Fig. 6
Beggar
(The Philospopher)
1865. Oil on canvas.
Collection of the Art
Institute of Chicago

and the spectacle of Spanish life delighted him; a disappointment because the dirt and bad food revolted this most fastidious of men. Had Manet been in a less discouraged state, curiosity might have triumphed over disgust. As it was, he did not stay longer than ten days in Madrid – enough time to develop a taste for bull-fighting and to discover that, while Goya did not live up to his expectations, Velázquez was 'the painter of painters'. 'The most extraordinary work of this splendid *oeuvre* (Manet wrote to Fantin-Latour) and perhaps the most astonishing painting ever done is the *Portrait of a Celebrated Actor of the Time of Philip IV*. The background disappears; the life-like figure dressed in black is surrounded by nothing but air . . . And what magnificent portraits! By contrast, Titian's *Charles V* seems made of wood.'

The outcome of this first-hand experience of Velázquez' work was a second phase of intense *Hispagnolisme*. The figure of *The Tragic Actor* (National Gallery of Art, Washington DC), which Manet painted after his return to Paris, is strongly reminiscent of the *Pablillos* (Fig. 17) and is steeped in the same airy, greyish element; while the two *Philosophers* (1865, Art Institute of Chicago; Fig. 6) and the *Rag-and-Bone Man* (Private Collection) – large, full-length character studies of old men against plain, darkish backgrounds – are directly inspired by Velázquez' *Aesop* and *Menippus* (both Prado, Madrid). Indeed, it is difficult not to feel that these interpretations of Velázquez are almost too literal; even their qualities – impressive old-masterish ones – remind us that they are among the few works by Manet which derive not from real life but from art. However, not all the paintings inspired by Manet's Spanish visit were so unoriginal. Three magnificent bullfighting scenes, started in October 1865, are entirely free of Velázquez' influence, being detached and naturalistic records, not vehicles for stylistic experiment, like so many others works of this phase. True, Manet has refreshed his memory by looking at Goya's *Tauromaquia* as well as at his own notes made in Madrid, but the vividness of these paintings bears out their origins in visual experience; and their naturalistic, seemingly casual compositions are much more satisfactory than those which Manet would have used before his Spanish journeys (Plate 12).

Much the same stylistic process can be followed if we compare the two works which Manet submitted, without success, to the Salon of 1866: *The Tragic Actor*, painted in the autumn of 1865, and *The Fifer* (Plate 13) of about six months later. Both paintings derive from Velázquez' *Pablillos*, in that both show figures 'surrounded by nothing but air'. But whereas the former only just escapes being a pastiche, *The Fifer* is a triumphantly original and daring synthesis of Spanish and Japanese elements – an advance even on *Olympia*. From Velázquez Manet has learnt how to conjure up an illusion of space out of an unrelieved expanse of grey paint and a slight shadow (behind the right foot), while from the Japanese he has learnt how to arrive at a simple, but expressive and harmonious arrangement of flattish forms. Among Manet's contemporaries, Zola was almost alone in seeing what the artist was aiming at: 'One of our great modern landscape-painters', he wrote, 'has said that this painting resembles an outfitter's signboard; I agree with him if he means by this that the boy's uniform has been treated with the simplicity of a popular print. The yellow of the braid, the blue-black of the tunic and the red of the trousers are just flat patches of colour. The simplification produced by the acute and perceptive eye of the artist has resulted in a canvas, all lightness and *naïveté*, charming to the point of elegance, yet realistic to the point of ruggedness.'

The harmony, clarity, economy and concentration on essentials which we find in *The Fifer* are features of all Manet's best paintings, but

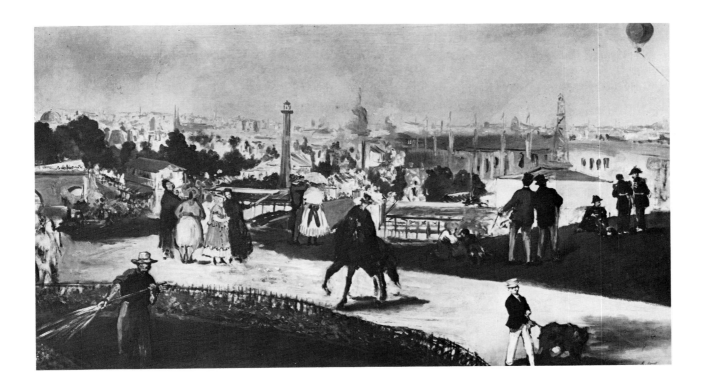

Fig. 7
View of the Exposition
Universelle
1867. Oil on canvas.
National Gallery, Oslo

more particularly of those done before 1869. Take, for instance, *The Execution of the Emperor Maximilian of Mexico* (Plate 14): how complex the incident Manet has chosen to depict, how concise the configuration! Yet the story is told dramatically, without rhetoric but with considerable pictorial effect. Likewise *Luncheon in the Studio* (Plate 19) of the following year; this is one of Manet's most complex compositions, but it is rendered with such simplicity (the cat, for instance, is reduced to a sort of black hieroglyph) that it appears wonderfully fresh and life-like. By contrast, a much later work like *The Conservatory* (Plate 39) although simple in composition, looks overloaded with detail and fussily painted.

One might think that such an intrinsically attractive work as *Luncheon in the Studio* would have found favour with the critics and public, but in fact each new work by Manet which they saw incited them to mockery or rage. In the face of the fiasco of his one-man show in 1867, repeated rejections from the Salon jury and vituperative attacks in the press, Manet, who had hitherto alternated between extremes of optimism and pessimism, lapsed into a state of self-doubt and gloom. He virtually abandoned the stylistic synthesis which he had but recently perfected, painted less, destroyed an increasing quantity of works while still unfinished (Tabarant lists a mere six paintings done in 1867 (Fig. 7), and only seven in 1868), and no longer dared ask anyone outside his family and intimate circle to pose for him.

At this critical juncture in his artistic development, Manet had only one consolation: a group of young admirers – Monet, Bazille, Renoir and Berthe Morisot – who hailed him as a great originator. He was friendly with all of them, but especially with Berthe Morisot. A product of the *haute bourgeoisie* like Manet himself, this intelligent and striking-looking girl appealed to him because she was an obliging model with dramatic, rather Spanish features and a habit of dressing in his favorite combination of black and white – as witness some of Manet's most hallucinating portraits (Plate 22). But because she was also a modern artist with a style of her own, she was in a position to teach Manet something as well as to learn from him. Amateurish and slapdash her work sometimes is, but her amateurishness was apt to be touched by genius.

Fig. 8
Portrait of Emile
Bellot
('Le Bon Bock')
1873. Oil on canvas.
Philadelphia Museum
of Art

We must also not forget that she was a great-great niece of Fragonard, as well as an ex-pupil of Corot: hence her freshness of vision and lightness of touch, qualities which significantly appear in Manet's paintings in 1869. Berthe Morisot was not of course the sole cause of Manet's change of idiom at the end of the 1860s – Monet, an infinitely more inventive artist, was also partly responsible – but I suspect that it was she who persuaded Manet to look at nature with a fresh eye and who was responsible for discouraging his obsession with stylistic considerations. All things considered, it is hard to feel that the inspired amateurishness and proto-Impressionist approach of his Egeria had an altogether improving effect on Manet's art, for with one or two notable exceptions (e.g. *The Harbour at Bordeaux* (Plate 23) and the magnificent portraits of Berthe Morisot (Plate 22)), the paintings of 1870-1 are sketchy and disturbingly eclectic in style. Had Manet been in better health or spirits, possibly his work would have been more vigorous and consistent, but the Siege of Paris, the Commune and the hysteria of post-war Paris life had left him in a wretchedly neurotic state. And the few paintings that date from this period of doubt and unrest reveal the artist wavering and seeking inspiration alternately in the works of Berthe Morisot, Goya and Monet, reverting briefly to his own 'flat' style of the mid-1860s, then finally, after a visit to Holland in the summer of 1872, launching into a Dutch style genre-piece, the *Portrait of Emile Bellot* (Fig. 8).

The *Portrait of Emile Bellot* is unique in Manet's *oeuvre*. It is more worked on than most, represents a deliberate attempt 'to make the critics swallow their words' – an attempt, it must be said, which succeeded, for when the picture was exhibited at the Salon of 1873 it was warmly praised – and lastly reveals the extent of Manet's temporary infatuation with the work of Hals and the Dutch *genre* painters. It also marks the end of a difficult period. Encouraged by having at last had a success at the Salon, by the fact that Durand-Ruel had recently bought a number of his paintings and, not least, by the gaiety which had returned to Paris with the Third Republic, Manet resumed painting scenes which would express some of the more agreeable aspects of contemporary life. Outstanding are *The Railway* (Plate 28) and *The Masked Ball at the Opéra* (Private Collection), a delightfully life-like *scène de moeurs* similar in composition and spirit to *Music in the Tuileries Gardens*. At the same time Manet found himself drifting more than ever into the orbit of the Impressionists. Here, however, we must tread carefully, for Manet's flirtation with members of this movement has been the cause of misunderstandings ever since the group was first dubbed '*la bande à Manet*' in the 1870s. Manet's stylistic discoveries, his rejection of a high academic finish, his use of pure colour and his naturalistic view of life had set an example which decisively influenced the Impressionists. But they owed no allegiance and over many fundamental problems, regarding the representation of light and optical reactions to colour, his views and theirs were diametrically opposed. The Impressionists were never in any real sense a '*bande à Manet*'; nor, as is so often claimed, was Manet in any real sense one of them. Manet never painted a truly Impressionist picture, that is to say one in which no black is used and colour is broken up into its complementaries, largely because he never visualised a scene purely in terms of light. For these reasons Manet always refused to exhibit with the Impressionists, preferring, as he said to stand or fall on his own at the Salon. Manet was only an Impressionist to the limited extent that, under the aegis of Monet and to a lesser degree of Renoir, he took to using a lighter palette, painting in stippled and broken brush strokes and experimenting more often than before with open-air subjects,

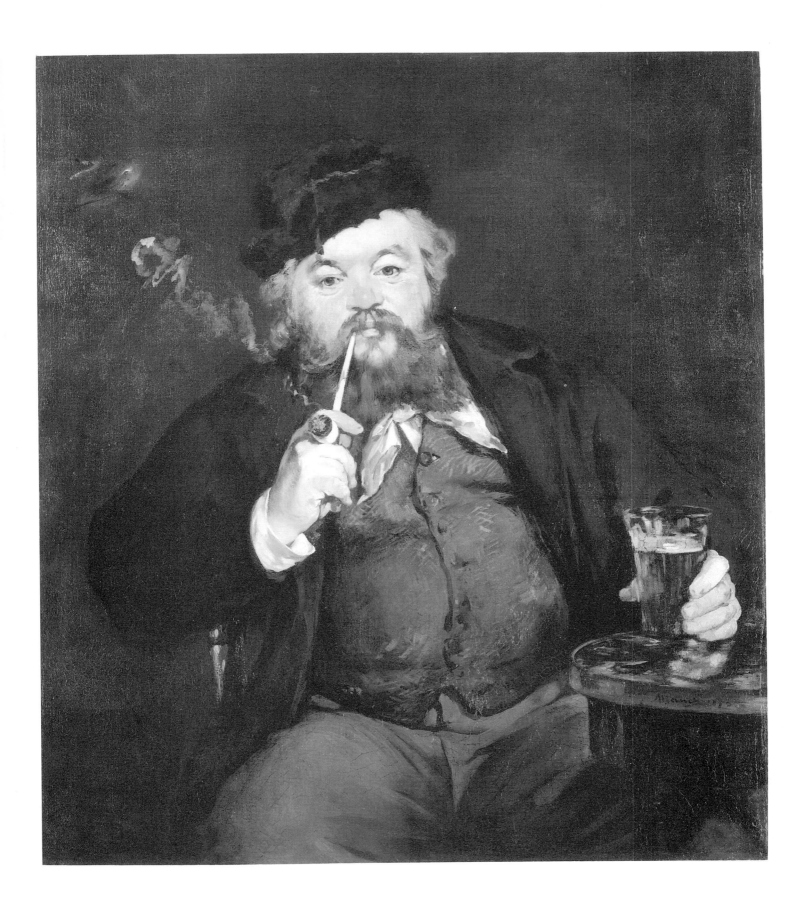

for example in *The Grand Canal, Venice* (Plate 32). Far from harming Manet's art, the Impressionist influence had a most beneficial effect; his finest compositions of the mid-1870s – *Argenteuil* (Plate 30), for instance – are more homogeneous in handling, richer and more varied in *facture* and more brilliant in tone than those of the previous decade. Defects there are in some of Manet's work of the period – a falling-off in intensity and a tendency to indulge in *belle peinture* for its own sake – but these have nothing to do with Impressionism. On the contrary, they stem partly from ill-health, partly from discouragement in the face of the intransigently hostile attitude of the critics, Salon jury and public and partly, one suspects, from Manet's growing friendship with the poet Mallarmé (Plate 33) who seems to have encouraged the artist's latent aestheticism, his Elstir-like tendency to cultivate the exquisite.

By 1877-8 Manet and the Impressionists had drifted, artistically speaking, apart. Manet reverted to doing *plein-air* scenes during the last two years of his life, it is true, but all his really great late works depict not nature but mankind, and the female of the species in particular. Now it is interesting that Manet should once have said that he never painted the quintessential woman of the Second Empire, but only of the Third Republic – interesting because at the very beginning of his career Manet already prided himself on being a 'painter of modern life'. Perhaps Manet would have painted life under the Second Empire more fully if he had felt less antipathy for the vulgar ostentation and totalitarianism of the epoch.

We have only to compare Manet with Degas to appreciate that whereas Degas shows us different aspects of an anonymous female animal – *l'éternal féminin* – Manet in his later works shows us the changing face of the Parisienne of the Third republic – variously a courtesan, *grande dame*, actress, barmaid, bourgeoise, intellectual spinster and street-girl. What is more, he has taken care to see that the costume, coiffure and pose are appropriate to the sitter and typical of the time (Fig. 9).

A chronicler of fashion? Yes, but also a chronicler of life. That is perhaps Manet's greatest quality. In his magnificent series of *genre* scenes of 1877 onwards – *Singer at a Café-Concert* (Plate 37), *Interior of a Café* (Plate 41), and *A Bar at the Folies-Bergère* (Plate 46), for example – one feels that Manet has somehow managed to stop the clock, for each of these works pins down for ever a moment of time in terms of great art. This is what distinguishes Manet from the lesser lights of his day – men like Tissot, Béraud and Stevens – who also set out to portray the passing show; this and the fact that Manet retained to the end his dispassionate and naturalistic vision. He always managed to see his period in perspective.

Manet's illness and premature death in 1883 were a much more serious blow for modern art than is generally realized. For, by the end of the 1870s, Manet had begun to take all kinds of daring pictorial liberties; had learnt how to obtain richer and more varied effects; had developed a more striking sense of colour; had considerably widened his imaginative range and had overcome his compositional failings. He himself seems to have felt that he was far from having nothing more to say, that, on the contrary, his best years lay ahead. And what is more likely? The Salon public was finally coming to tolerate his novel style and vision, and it is more than probable that popular success would have spurred him on to excel himself. *A Bar at the Folies-Bergère*, his culminant work, opens up tantalizing vistas of unpainted masterpieces, of a series of stupendous allegorical scenes of modern life which he envisages.

Alas, instead of going on to paint more and more ambitious pictures, Manet was condemned by illness to work on an increasingly restricted scale – hence the impressionistic garden-scenes, the pastel portraits and flowerpieces of 1880-3 (Plate 48) – until in the last year of his life he seriously considered taking up miniature painting. This was Manet's tragedy – a more bitter tragedy, to my mind, than the blindness of Monet and Degas, more bitter even than the early deaths of Seurat and Toulouse-Lautrec, because each of these artist had been able to create an *oeuvre* that is homogeneous and complete. Manet was a great originator, a great executant, a great artist and a great influence; nevertheless the *oeuvre* which he left behind is, in the last resort, incomplete and only partly fulfilled.

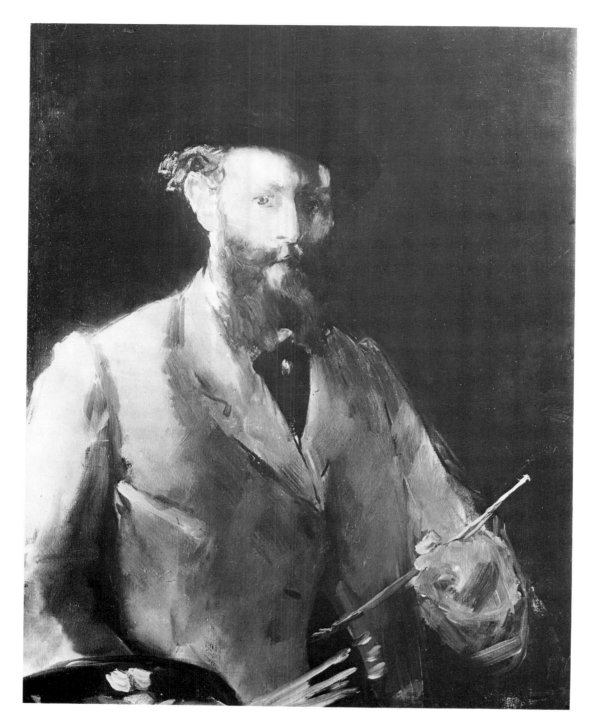

Fig. 10
**Self-Portrait with
a Palette**
1879. Oil on canvas.
Private collection

Outline Biography

1832 Born 23 January at 5 rue des Petits-Augustins, Paris. His father, Auguste, is employed by the Ministry of Justice. His mother, Eugénie-Désirée, née Fournier, is the daughter of a diplomat.

1839-44 At the Poiloup school in Vaugirard. Makes his first attempts at drawing under the guidance of his uncle, Edmond-Eduoard Fournier.

1844 Enter the Collège Rollin, where he meets Antonin Proust, a lifelong friend.

1848 Completes his studies at the Collège Rollin. Goes to sea on the cadet ship *Le Havre et Guadeloupe*.

1849 April: In Rio de Janeiro. Fails his naval examinations. Decides to become a painter and enrols in the studio of Thomas Couture.

1850-6 Attends the studio of Thomas Couture.

1853 Visits Italy.

1856 Travels to Holland, to Germany, visiting Munich and Dresden, to Vienna, and to Italy, visiting Florence, Rome and Venice.

1861 *The Spanish Singer* is accepted at the Salon and wins an honourable mention.

1862 Meets Victorine Meurent who frequently serves as his model.

1863 February-March: exhibits at Louis Martinet's gallery. His submissions to the Salon are rejected and appear at the Salon des Refusés. *The Picnic* is the focus of scandalized critical and public attention. 28 October: Marries Suzanne Leenhoff in Holland.

1864 Spends the summer at Boulogne-sur-Mer.

1865 February: Exhibits new work at Martinet's gallery. August: Visits Spain, where he meets Théodore Duret.

1867 Exhibits in a pavilion in the garden of the Marquis of Pomereux, on the avenue Alma. Spends summers at Boulogne-sur-Mer and Trouville.

1868 At Boulogne-sur-Mer, begins *Luncheon in the Studio*.

1869 Meets Eva Gonzalés, whom he accepts as a student.

1870 December: Joins National Guard.

1871 Rejoins his family at Oloron. Visits Bordeaux, then spends a month at Arcachon. May: Returns to Paris, where he finds studio partly wrecked.

1872 Sells his first paintings to Durand-Ruel. Moves to a new studios at 4 rue de Saint-Pétersbourg. August: Visits Holland.

1873 *Le Bon Bock* achieves considerable success at the Salon. Meets Stéphane Mallarmé.

1874 July: Spends two weeks at Montgeron with the Hoschedé family, then visits Fécamp.

1878 Begins to be troubled by pain is his left leg. Leaves his studio at 4 rue de Saint-Pétersbourg and rents the studio of Count Otto Rosen.

1879 April: Moves into his new studio at 77 rue d'Amsterdam. Experiences renewed pains in his leg and visits a clinic at Bellevue.

1880 April: Exhibits new works at *La Vie Moderne*. Spends several months at Bellevue, in the villa of the singer Emilie Ambre. Returns to Paris in November.

1881 Exhibits his portraits of Henri Pertuiset and of Rochefort at the Salon, obtains second class medal and now '*hors concours*'. June: Moves to a villa at Versailles. On the recommendation of Antonin Proust, now Minister of Fine Arts in Gambetta's cabinet, is awarded the *Légion d'Honneur*.

1882 Exhibits for the last time at the Salon, showing *Spring* and *A Bar at the Folies-Bergère*. July-October: Lives at Ruèil.

1883 14 April: Gangrene sets in in his left leg, and the surgeon decides to amputate. 30 April: Manet dies.

Select Bibliography

COMPLETE CATALOGUES OF MANET'S PAINTINGS

G. Wildenstein, P. Jamot, and M-L. Bataille, *Manet* (2 vols.), Paris, 1932

D. Wildenstein and D.Rouart, *Manet* (2 vols.), Paris, 1975

MONOGRAPHS

P. Courthion and P.Cailler (eds), *Portrait of Manet by Himself and his Contemporaries*, London, 1960

T. Duret, *Histoire d'Eduoard Manet and de son œuvre*, Pairs, 1902; Paris, 1919 with catalogue supplement

G.H. Hamilton, *Manet and His Critics*, New York, 1969

A.C. Hanson, *Manet and the Modern Tradition*, London, 1977

J.C. Harris, *Edouard Manet: Graphic Works*, New York, 1970

G. Mauner, *Manet, Peintre-Philosophe*, University Park and London, 1975

E. Moreau-Nélaton, *Manet raconté par lui-même* (2. vols), Paris, 1926

S. Orienti, *The Complete Works of Edouard Manet*, London, 1972

H. Perruchot, *Manet*, London, 1962

T.Reff, *Manet: Olympia*, London 1976

J. Rewald, *The History of Impressionism*, 4th edition, London and New York, 1974

PERIODICAL ARTICLES

A. Boime, 'New Light on Manet's "Execution of Maximilian"', *Art Quarterly*, XXXVI (1973), 172-208

A. Bowness, 'A note on Manet's "Compositional Difficulties"', *The Burlington Magazine*, CIII (1961), 276-7

T.J.Clark, 'Preliminaries to a Possible Treatment of "Olympia" in 1865', *Screen*, Vol.21 (1980), 18-42

B.R. Collins, 'Manet's Luncheon in the Studio"', *Art Journal*, Winter 1978/9, 107-13

A. De Leiris, '"Sur la plage de Boulogne"', *Gazette des Beaux-Arts*, LVII (1961), 53-62

M. Fried, 'Manet's Sources: Aspects of his Art, 1859-1865', *Artforum*, VII (1969)

J.C. Harris, 'Manet's Racetrack Paintings', *Art Bulletin*, XLVIII (1966), 78-82

T.Reff, 'On Manet's Sources', *Artforum*, VII (1969), 40-8

EXHIBITION CATALOGUES.

Edouard Manet and the 'Execution of Maximilian', an exhibition by the Department of Art, Brown University, Providence, Rhode Island, 1981

Manet and Spain, catalogue by J.S. Harris and J. Isaacson, The University of Michigan, Ann Arbor, Michigan, 1969

List of Illustrations

Colour Plates

1. The Absinthe Drinker
 1858-9. Oil on canvas, 181 x 106 cm.
 Ny Carlsberg Glyptotek, Copenhagen

2. The Street Singer
 c.1862. Oil on canvas, 175 x 109 cm.
 Museum of Fine Arts, Boston

3. The Old Musician
 c.1862. Oil on canvas, 188 x 249 cm. Chester Dale
 collection, National Gallery of Art, Washington DC

4. Lola de Valence
 1862. Oil on canvas, 123 x 92 cm.
 Musée d'Orsay, Paris

5. Music in the Tuileries Gardens
 1862. Oil on canvas, 76 x 118 cm.
 National Gallery, London

6. The Picnic ('Le Déjeuner sur l'Herbe')
 1862-3. Oil on canvas, 208 x 264 cm.
 Musée d'Orsay, Paris

7. Olympia
 1863. Oil on canvas, 130 x 190 cm.
 Musée d'Orsay, Paris

8. The Battle of the Kearsarge and the
 Alabama
 1864. Oil on canvas, 134 x 127 cm.
 The John G. Johnson collection, Philadelphia

9. Still life with Eel and Red Mullet
 1864. Oil on canvas, 38 x 46 cm.
 Musée d'Orsay, Paris

10. Peonies in a Vase
 c.1864. Oil on canvas, 93 x 70 cm.
 Musée d'Orsay, Paris

11. Women at the Races
 1864-5. Oil on canvas, 41 x 31 cm.
 Cincinnati Art Museum

12. Bull-Fighting Scene
 1865-6. Oil on canvas, 90 x 110 cm.
 Private collection

13. The Fifer
 1866. Oil on canvas, 161 x 97 cm.
 Musée d'Orsay, Paris

14. The Execution of the Emperor Maximilian
 of Mexico
 1867-8. Oil on canvas, 252 x 305 cm.
 Städtische Kunsthalle, Mannheim

15. Soldier (fragment of 'The Execution of
 Maximilian')
 1867-8. Oil on canvas, 99 x 59 cm.
 National Gallery, London

16. Portrait of Emile Zola
 1867-8. Oil on canvas, 146 x 114 cm.
 Musée d'Orsay, Paris

17. Portrait of Théodore Duret
 1868. Oil on canvas, 43 x 35 cm.
 Musée du Petit Palais, Paris

18. The Balcony
 1868. Oil on canvas, 170 x 125 cm.
 Musée d'Orsay, Paris

19. Luncheon in the Studio
 1868. Oil on canvas, 120 x 153 cm.
 (Neue Pinakothek), Bayerische
 Staatsgemäldesammlungen, Munich

20. Beach at Boulogne-sur-Mer
 1869. Oil on canvas, 33 x 65 cm.
 Mr and Mrs Paul Mellon collection, Upperville,
 Virginia

21. The Reading
 1869. Oil on canvas, 61 x 74 cm.
 Musée d'Orsay, Paris

22. Repose (Berthe Morisot)
 1869-70. Oil on canvas, 148 x 111 cm.
 Rhode Island School of Design, Museum of Art,
 Providence, Rhode Island

23. The Harbour at Bordeaux
 1871. Oil on canvas, 65 x 100 cm.
 Foundation E.G. Bührle collection, Zurich

24. Nude
 c.1872. Oil on canvas, 60 x 49 cm.
 Musée d'Orsay, Paris

25. Berthe Morisot
 1872. Oil on canvas, 55 x 38 cm.
 Private collection

26. Racecourse in the Bois de Boulogne
 1872. Oil on canvas, 73 x 92 cm. Private collection

27 Marguerite de Conflans Wearing a Hood
 c.1873. Oil on canvas, 56 x 46 cm. Oskar Reinhart
 collection 'Am Römerholz', Winterthur

28 The Railway
 1873. Oil on canvas, 93 x 114 cm.
 Collection H. O. Havemeyer Bequest, National
 Gallery of Art, Washington DC

29 Claude Monet Painting on his Studio Boat
 1874. Oil on canvas, 80 x 98 cm. (Neue Pinakothek),
 Bayerische Staatsgemäldesammlungen, Munich

30. Argenteuil
 1874. Oil on canvas, 149 x 131 cm.
 Musée des Beaux-Arts, Tournai

31. Boating
 1874. Oil on canvas, 96 x 130 cm.
 Mrs H.O. Havemeyer collection, The Metropolitan
 Museum of Art, New York

32. The Grand Canal, Venice
 1874. Oil on canvas, 57 x 48 cm. Property of the
 Provident Securities Company, San Francisco

33. Portrait of Stéphane Mallarmé
 1876. Oil on canvas, 27.5 x 36 cm.
 Musée d'Orsay, Paris

34. Nana
 1877. Oil on canvas, 150 x 116 cm.
 Kunsthalle, Hamburg

35. The Road-menders, Rue de Berne
 1878. Oil on canvas, 63 x 79 cm. Private collection

36. Blonde with Bare Breasts
 c.1878. Oil on canvas, 62.5 x 51 cm.
 Musée d'Orsay, Paris

37. Singer at a Café-Concert
 c.1878-9. Oil on canvas, 73 x 92 cm.
 Rouart collection, Paris

38. The Waitress
 c.1879. Oil on canvas, 77.5 x 65 cm.
 Musée d'Orsay, Paris

39. The Conservatory
 1878-9. Oil on canvas, 115 x 150 cm.
 Staatliche Museen, Berlin

40. At Père Lathuille's
 1879. Oil on canvas, 93 x 112 cm.
 Musée des Beaux-Arts, Tournai

41. Interior of a Café
 c.1880. Oil and pastel on linen, 32 x 45 cm.
 The Burrell collection, Glasgow Museums and Art
 Galleries

42 The Ham
 c.1880. Oil on canvas, 32 x 42 cm.
 The Burrell collection, Glasgow Museums
 and Art Galleries

43. Portrait of Henri Rochefort
 1881. Oil on canvas, 81.5 x 66.5 cm.
 Kunsthalle, Hamburg

44. Clematis in a Crystal vase
 c.1881. Oil on canvas, 56 x 35.5 cm.
 Musée d'Orsay, Paris

45. Autumn (Méry Laurent)
 1881. Oil on canvas, 73 x 51 cm.
 Musée des Beaux-Arts, Nancy

46. A Bar at the Folies-Bergère
 1882. Oil on canvas, 96 x 130 cm.
 Courtauld Institute Galleries, London

47. Villa at Rueil
 1882. Oil on canvas, 92 x 73 cm.
 National Gallery of Victoria, Melbourne

48. Roses and Tulips in a Vase
 c.1882. Oil on canvas, 54 x 33 cm.
 Foundation E.G. Bührle collection, Zurich

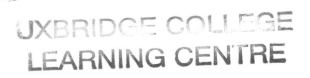

Text Figures

Comparative Figures

11. Detail of 'The Old Musician' (Plate 3)

12. Courbet: The Painter's Studio
 1855. Oil on canvas.
 Musée du Louvre, Paris

13. Titian: The Venus of Urbino
 c.1538. Oil on canvas. Uffizi, Florence

14. Peonies
 1864. Oil on canvas. Musée d'Orsay, Paris

15. Racecourse at Longchamp
 1864. Gouache and watercolour on paper.
 Grenville L. Winthrop Bequest, Fogg Art Museum,
 Harvard University, Cambridge, Mass

16. Torero Saluting
 1866. Oil on canvas. Metropolitan Museum of Art,
 New York

17. Velázquez: Pablillos de Valladolid
 c.1632. Oil on canvas. Museo del Prado,
 Madrid

18. Goya: 3 May 1808
 1814. Oil on canvas.
 Museo del Prado, Madrid

19. Portrait of Zacharie Astruc
 1864. Oil on canvas. Kunsthalle, Bremen

20. Woman with a Parrot
 1866. Oil on canvas.
 Metropolitan Museum Of Art, New York

21. Madame Edouard Manet at the Piano
 1868. Oil on canvas. Musée d'Orsay, Paris

22. Portrait of Eva Gonzalès
 1870. Oil on canvas. National Gallery, London

23. The Departure of the Folkestone Boat
 1869. Oil on canvas.
 Museum of Art, Philadelphia

24. Degas: Carriage at the Races
 c.1870-2. Oil on canvas.
 Museum of Fine Arts, Boston

25. Detail of 'The Game of Croquet'
 1873. Oil on canvas.
 Städelsches Kunstinstitut, Frankfurt

26. The Banks of the Seine at Argenteuil
 1874. Oil on canvas.
 Private collection, (on loan to the National Gallery,
 London)

27. Blue Venice
 1874. Oil on canvas.
 Shelburne Museum, Shelburne, Vermont

28. The Plum
 1877. Oil on canvas. Mellon collection, National
 Gallery of Art, Washington DC

29. Rue de Berne
 1878. Pencil and wash on paper.
 Museum of Fine Art, Budapest

30. Madame Edouard Manet in the
 Conservatory
 1879. Oil on canvas. National Gallery, Oslo

31. Renoir: Detail of 'The Luncheon of
 the Boating Party'
 1881. Oil on canvas.
 The Phillips collection, Washington DC

32. Woman with a Black Hat
 1882. Pastel. Musée d'Orsay, Paris

33. Portrait of Clemenceau
 1879. Oil on canvas. Musée d'Orsay, Paris

34. Spring: Jeanne
 1881. Oil on canvas. Private collection

35. Detail of 'A Bar at the Folies-Bergère'
 (Plate 46)

1 The Absinthe Drinker

1858-9. Oil on canvas, 181 x 106 cm. Ny Carlsberg Glyptotek, Copenhagen

This painting marked the end of Manet's ties with Thomas Couture, who disapproved of Manet's attempt at naturalism, as did the 1859 Salon jury. Antonin Proust quoted Manet as saying: 'I have done a Parisian type, studied in Paris, putting into it the simplicity of craft which I discovered in Velázquez. No one understands it. If I painted a Spanish type, it would be better understood.'

The model for the painting was a *chiffonier* called Colardet, who was well known in the area around the Louvre. Manet's inclusion of the full glass and the empty bottle serves to provide the viewer with more information about the top-hatted figure and is the first instance of his use of still-life objects which take on the rôle of attributes (see also the *Portrait of Emile Zola*, Plate 16). Already in this early work Manet was commenting on the anonymity created by the prevailing men's fashion, adopted after the 1848 revolution, for black or dark suits without decoration, and was to do so again in paintings such as *Music in the Tuileries Gardens* (Plate 5). The rag picker in his tattered cloak and trousers is almost a parody of the dandy, as well as an object lesson in the effect of prolonged absinthe drinking, already widely recognized at this time.

The idiom of this work derives from Daumier, the subject-matter from Baudelaire, whose approbation Manet sought without success: 'Admit that I was entirely myself in the *Absinthe Drinker*', he pleaded, 'Euh! euh!' was the only reply. In addition, Manet had copied Adrian Brouwer's drinker already apparently mad from absinthe.

Manet incorporated the figure of the absinthe drinker in *The Old Musician* (Plate 3).

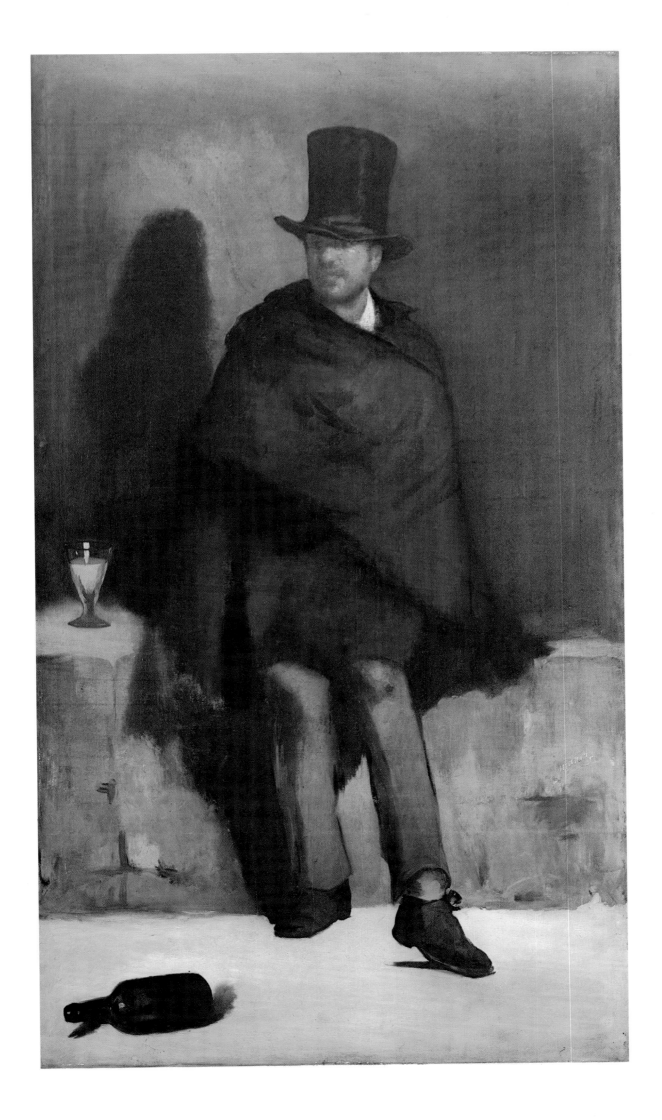

The Street Singer

c.1862. Oil on canvas, 175 x 109 cm. Courtesy of the Museum of Fine Arts, Boston

Manet's friend Antonin Proust described a walk they once took together through an old part of Paris which was being demolished to make way for Baron Haussmann's new Malesherbes *quartier*: 'A woman stepped out of a low tavern holding up her dress and carrying a guitar. Manet went straight up to her and asked her to pose for him. She merely laughed. "I'll have another go," he said, "and if she doesn't want to pose, I'll ask Victorine."'

Victorine Meurent (or Meurand) was Manet's favourite model in the 1860s, posing for such important works as *The Picnic* (Plate 6) and *Olympia* (Plate 7). She went to America in mysterious circumstances in the 1860s and then returned to France, serving again as Manet's model in the early 1870s, for example in *The Railway* (Plate 28). She became a painter herself, exhibiting a self-portrait at the 1876 Salon when Manet's submission was rejected, and in the 1879 Salon her entry was in the same room as Manet's.

In this painting Manet portrays a Parisian type, described by Victor Fournel in *Ce qu'on voit dans les rues de Paris* (1858) as being typically like a 'statue of resigned misery'. Manet's figure has a blank, remote expression, looking directly at the viewer but without any acknowledgement of his presence. The painting is harshly lit so that the face appears almost as a mask pierced by dark, wide-set eyes, and the scarlet of the cherries and their yellow wrapping create vivid colour accents in the overall drab browns, grey and green of the scene. The harsh lighting outlines the figure and separates her from the background, suggesting the beginnings of the influence of Japanese prints in Manet's work, combined with his enduring love of Spanish art.

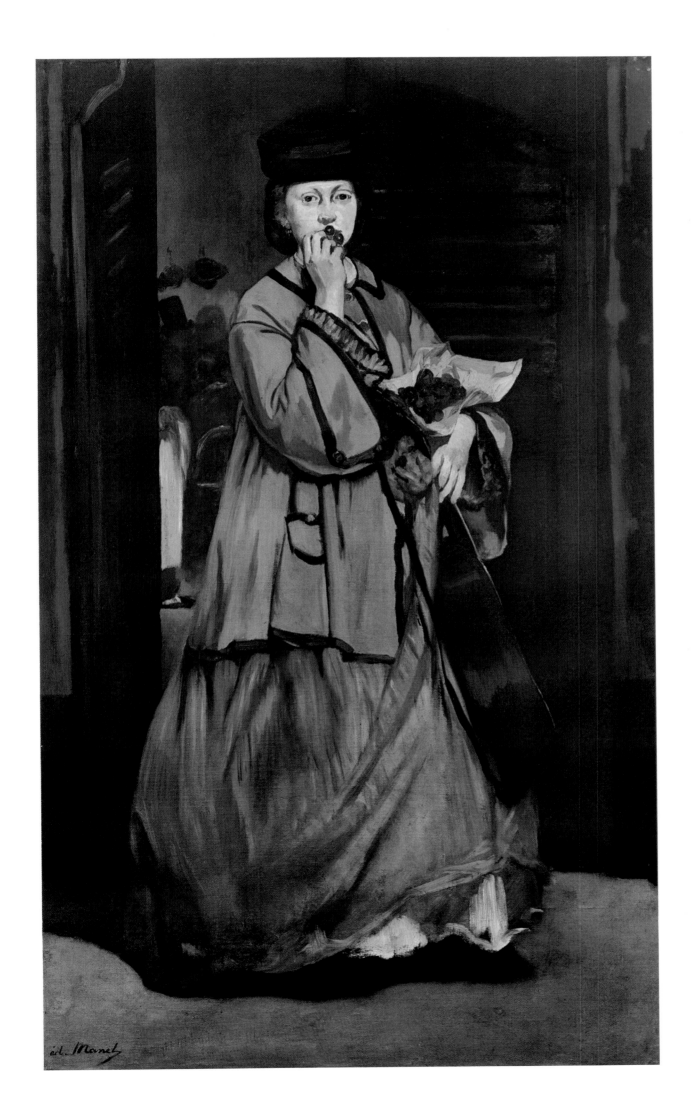

The Old Musician

c.1862. Oil on canvas, 188 x 249 cm. Chester Dale collection, National Gallery of Art, Washington DC

Fig. 11
Detail of 'The Old Musician'

c.1862. Oil on canvas.
Chester Dale collection,
National Gallery of Art,
Washington DC

At the time of its completion in 1862 this painting was Manet's most ambitious work to date. It brings together many of the influences on his early work, and includes the figure from one of his earlier paintings, *The Absinthe Drinker* (Plate 1). There has been considerable debate about the artistic sources for this painting. Michael Fried, in a major article on Manet's sources (*Artforum*, March 1969) claimed Louis le Nain's *Halte du Cavalier* as an overall influence. Theodore Reff, in a reply to Fried (*Artforum*, September 1969), prefers Antoine le Nain's *Old Piper*. Alain de Leiris (*Art Bulletin*, XLVI, 1964) pointed out that the figure of the old musician depends in part on Velázquez' *Drinkers*, and in part on a Roman replica of a Greek portrait of *Chrysippos* (whom Manet knew to be a philosopher), which Manet had copied in the Louvre. Attention has also focused on the sources for the two boys (Fig. 11), and on the resemblance between the smaller boy's costume and that worn by Watteau's *Gilles*, equating Manet's figure with Pierrot.

The disparateness of the painting and the synthetic process of its creation justifies the search for artistic sources, but the brightening tonality of the work is an indication that Manet was beginning to rely increasingly on visual information obtained from direct observation of the people of Paris. The musician of the title was posed by a man called Guéroult, whom Manet found in a ghetto area known as 'Little Poland', close to his studio in the rue Guyot.

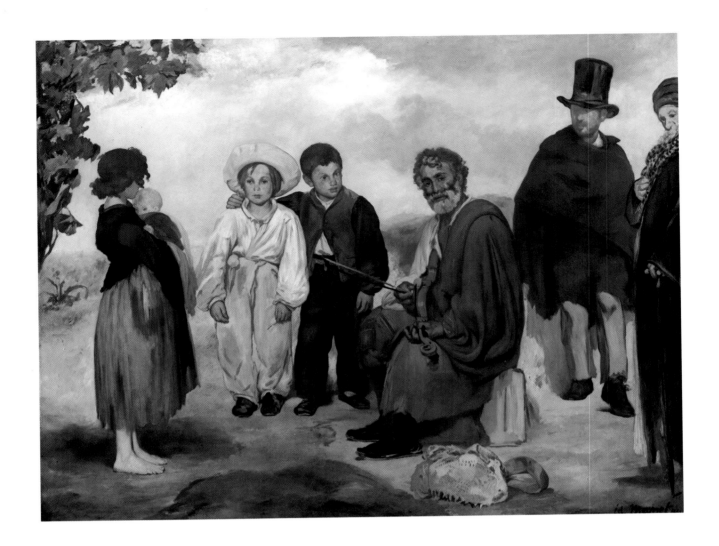

4 Lola de Valence

1862. Oil on canvas, 123 x 92 cm. Musée d'Orsay, Paris

The dance company of Camprubi performed at the Hippodrome at the Porte Dauphine during the summer of 1862. The *première danseuse*, Lola Melea, known as Lola de Valence, is the subject of this painting, which was shown at Manet's exhibition at Martinet's gallery in 1863. Manet induced Camprubi to bring his dancers to the studio of his friend the Belgian painter Alfred Stevens during their leisure hours, and they posed for him there.

Baudelaire greatly admired the Camprubi company and is said to have attended all their performances. A quatrain by Baudelaire subtitled 'Inscription for the painting by Edouard Manet' was attached to the engraved version of this subject:

Entre tant de beautés que partout on peut voir
Je comprends bien, amis, que le désir balance,
Mais on voit scintiller dans Lola de Valence
Le charme inattendu d'un bijou rose et noir.

Zacharie Astruc (see Fig. 19), the poet, critic, amateur sculptor and musician, whose admiration for things Spanish extended to his moving to Madrid, wrote a song called *Lola de Valence* and Manet executed a lithograph after this portrait for its cover.

The engraving of Lola has a plain background, as the painting originally had, but Manet altered his canvas so that Lola appears in the wings, ready to go on stage, and the front of stage and the audience is glimpsed on the extreme right of the painting. Lola's proud pose may make some reference to Goya, but essentially Manet's painting is a record of the dancer herself, as he observed her.

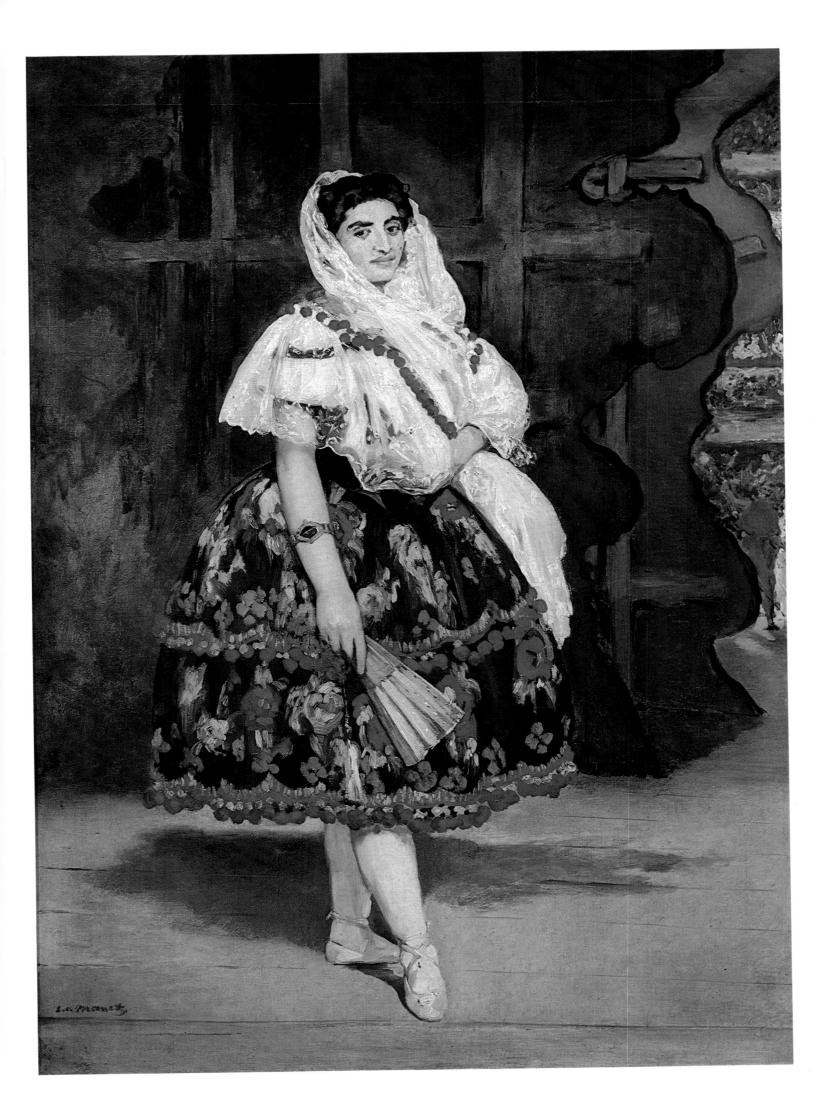

1862. Oil on canvas, 76 x 118 cm. National Gallery, London

This painting expresses Manet's friend Charles Baudelaire's concept of the heroism of modern life, which he first wrote about in his *Salon of 1845*, when he anticipated the emergence of a painter 'who will know how to wrest from actual life its epic side and will make us see and understand with colour and with drawing how grand we are in our neckties and our varnished boots'. A year later, Baudelaire described the dark clothing worn by Parisian men after the 1848 revolution as 'the outer husk of the modern hero'. Manet included a portrait of Baudelaire in his study of *la vie moderne*, presenting a crowd of fashionably dressed people enjoying an open-air concert in the Tuileries Gardens.

The painting may be compared to Courbet's mammoth *The Painter's Studio* (Fig. 12) for, like Courbet, Manet portrays himself surrounded by his friends and associates. Whereas Courbet is assertively in the centre of his own painting, Manet is to be found at the extreme left of this canvas. Other identifiable figures include Zacharie Astruc (see Fig. 19), the composer Offenbach, Théophile Gautier, Henri Fantin-Latour, Manet's friend the painter Albert de Balleroy, and his brother Eugène Manet, who was later to become Berthe Morisot's husband.

The painting is also related to *The Little Cavaliers*, thought in Manet's time to be by Velázquez, which represents artists who were contemporaries of Velázquez, with Murillo and Velázquez himself on the far left of the group. Manet had copied this work in an etching of 1860 (see Fig. 3).

Music in the Tuileries Gardens departs from traditional concepts of composition, for the centre area is almost illegible, close study being required to reveal that the standing male figure, probably Eugène Manet, is talking to a seated veiled woman, and equal importance is given to the figures and to details such as the umbrella in the foreground.

Fig. 12
Gustave Courbet:
The Painter's
Studio

1855. Oil on canvas,
359 x 598 cm.
Musée du Louvre, Paris

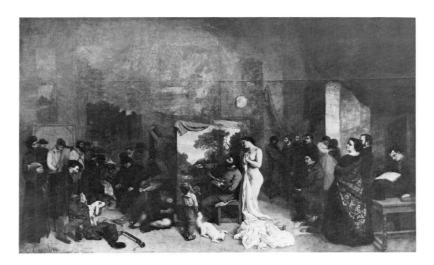

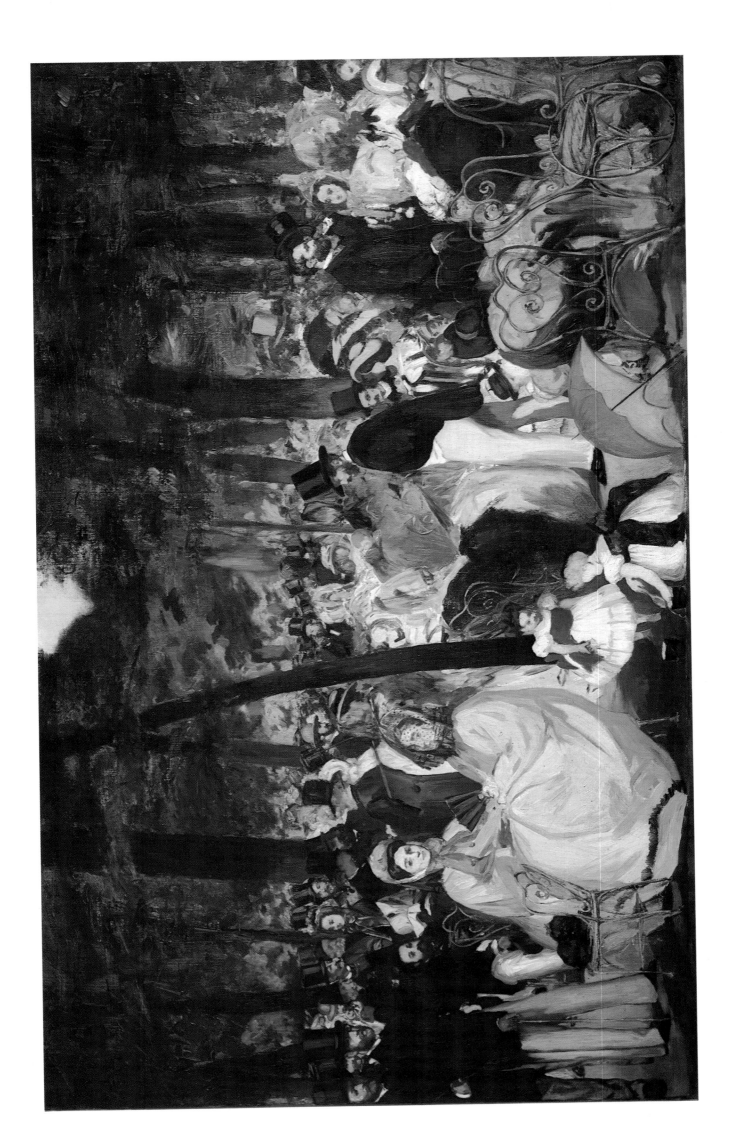

The Picnic ('Le Déjeuner sur l'Herbe')

1862-3. Oil on canvas, 208 x 264 cm. Musée d'Orsay, Paris

The Picnic was savaged by most critics at the 1863 Salon des Refusés; Louis Etienne's remarks in *Le Jury et les exposants* are representative of the critical reaction:

'A commonplace woman of the *demi-monde*, as naked as can be, shamelessly lolls between two dandies dressed to the teeth . . . This is a young man's practical joke, a shameful open sore not worth exhibiting this way.' Fernand Desnoyers in *La Peinture en 1863* was more balanced in his comments:

'Manet's three pictures [the other two were *Mlle Victorine in the Costume of an Espada* and *Young Man in the Costume of a 'Mayo'*] must have profoundly upset the dogmatic ideas of the jury. The public also has not failed to be astonished by this kind of painting which at the same time aggravates art lovers and makes art critics facetious. You can consider it evil but not mediocre. Manet certainly has not the least bias. He will keep on because he is sure of himself in the long run, whatever the art lovers claim they find in his manner imitative of Goya or of Couture – small difference that makes. I believe that Manet is indeed his own master. That is the finest praise one can give him.'

Despite the painting's references to the history of art, to Giorgione's *Fête Champêtre* (Louvre, Paris) and to Marcantonio Raimondi's engravings after Raphael's *Judgement of Paris*, the contemporaneity of the painting was the main reason for the public's bewilderment and rage. Manet's friend Proust claimed that the germ of the idea for the painting, originally called *Le Bain*, had come from observing the bathers at Argenteuil. Proust said that Manet had told him that he would like to re-do Giorgione's picture and 'make it translucent, using models like those people we see over there'. The models for the eventual painting, Victorine Meurent, Manet's brother Gustave, and his future brother-in-law Ferdinand Leenhoff, could have been spotted moving among the crowds that gathered to jeer at the painting at the Salon des Refusés.

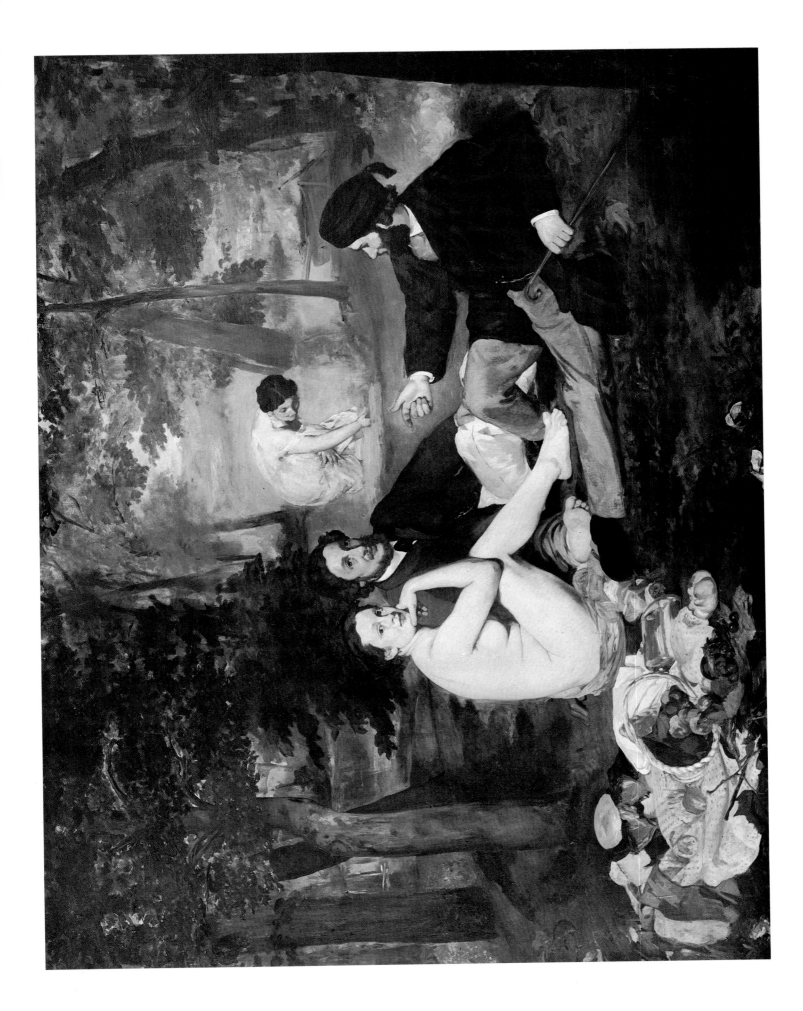

Olympia

1863. Oil on canvas, 130 x 190 cm. Musée d'Orsay, Paris

Olympia was exhibited at the 1865 Salon and was quickly named 'Venus with a Cat'. For years afterwards the bitter hostility that the painting aroused pursued Manet, to the extent that cartoonists used a black cat as a symbol of his art. The relationship between the painting and Titian's *Venus of Urbino* (Fig. 13), which Manet had copied as a student (c.1853), and which was believed to be a painting of a courtesan, was not generally recognized. When it was, the comparison was derogatory:

'. . . a woman on a bed, or rather some form or other blown up like a grotesque in indiarubber; a sort of monkey making fun of the pose and the movement of the arm of Titian's Venus, with a hand shamelessly flexed . . .' (*Les Tablettes de Pierrot*).

The models for Manet's painting were Victorine Meurent and a negress called Laure. Manet's contemporary version of the odalisque and slave theme was accompanied by five lines of verse inscribed on the frame and printed in the Salon catalogue, as if as a statement of Manet's intentions:

Quand, lasse de rêver, Olympia s'éveille
Le printemps entre au bras du doux messager noir;
C'est l'esclave, à la nuit amoureuse pareille,
Qui vient fleurir le jour délicieux à voir:
L'auguste jeune fille en qui la flamme veille.

These lines, from a long poem called 'La Fille des îles' written by Zacharie Astruc, further increased the confusion of the critics.

Manet's *Olympia*, with a pedigree of related nude paintings in French, Italian and Spanish art behind her, is unmistakably of her own time. Her direct, unwavering, and unavoidable gaze (which appears to follow the spectator around the room) implies a self-confidence, even arrogance at variance with accepted notions of paintings of the female nude.

Fig. 13
Titian:
The Venus of
Urbino

c.1538. Oil on canvas,
119 x 165 cm.
Uffizi, Florence

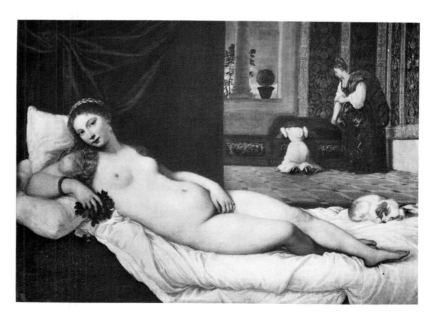

The Battle of the Kearsarge and the Alabama

1864. Oil on canvas, 134 x 127 cm. The John G. Johnson Art Collection, Philadelphia

In 1864 the American Confederate cruiser *Alabama* took refuge in Cherbourg harbour to avoid the Union corvette, the *Kearsarge*. The captain of the *Alabama*, Captain Sammes, eventually determined to run the blockade and on 19 June 1864 the battle took place. Crowds had gathered in Cherbourg to watch the confrontation, and a number of boats stationed themselves near the combatants to see the fight at close quarters. Proust and Tabarant claim that Manet himself was on one of these boats, an eye witness to the scene, but this is uncertain. As in *The Execution of the Emperor Maximilian* (Plate 14), Manet declares his interest in depicting events of contemporary history in his work.

The painting was exhibited at the Salon of 1872, and was praised by the distinguished novelist and critic Jules Barbey d'Aurevilly. He wrote:

'. . . I have been affected, before this painting, by a sensation I didn't think Manet capable of dealing me. It is a feeling of nature and landscape, very simple and very powerful. . . . Here in making this picture – a picture of war and assault which he has conceived and executed with the tension of a man who wants by all means to escape from the frightful conventionality in which we are all submerged – whatever is most natural, most original, what has been in reach of every brush since the world began, that Manet has best expressed in his painting of the *Kearsarge and the Alabama* . . . A very fair thing this is, in conception and execution! Manet, in spite of the vaunted and execrable culture which corrupts us all, can become a great painter of nature. Today with his seascape of the *Alabama* he has married Nature herself! He has done it like the Doge of Venice; he has thrown a ring, which I swear is a golden one, into the sea.'

The painting was formerly in the collection of the publisher Georges Charpentier, whose sister-in-law, Isabelle Lemonnier, Manet painted on several occasions. In 1880 Charpentier held an exhibition of 'New Works by Edouard Manet' at his gallery, *La Vie moderne*.

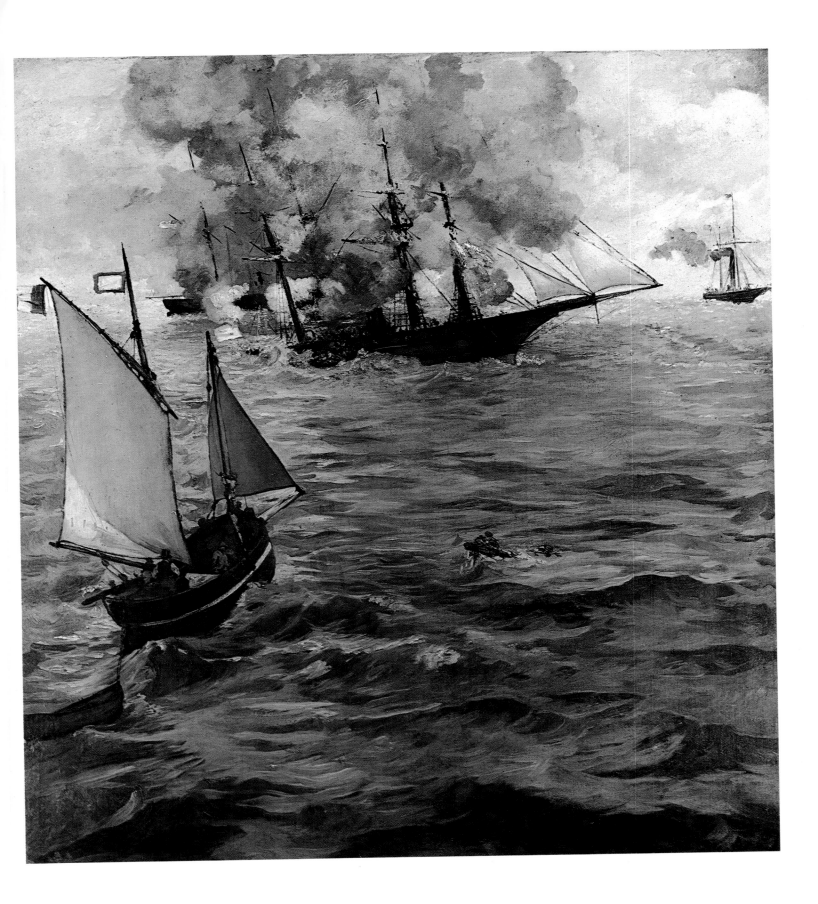

9 Still Life with Eel and Red Mullet

1864. Oil on canvas, 38 x 46 cm. Musée d'Orsay, Paris

Manet probably painted this small canvas while he was at Boulogne-sur-Mer in the summer of 1864. As is revealed in many of Manet's major paintings, for example *The Picnic* (Plate 6) or *A Bar at the Folies-Bergère* (Plate 46), still life was a category of painting that greatly interested Manet. Here, the glistening fish are flung apparently at random on the kitchen table, awaiting the attentions of the cook's knife that lies on the white cloth, its handle extended towards the spectator. Closer examination, however, reveals the composition to be a careful and undoubtedly deliberate arrangement of forms, the dark eel's sinuous curves against the pink-silver solidity of the mullet, the angle of the knife parallel to the head of the eel, the knife making a dark contrast to the white cloth.

Even in a small, quickly executed painting such as this (note the approximate indication of the tablecloth by a few bold strokes of the brush), Manet overlays acute direct observation with references to the history of art. The simplicity of arrangement, the enjoyment of the appearance of the food, and the homeliness of the setting suggest the influence of Jean-Baptiste-Siméon Chardin, whose work was enjoying a revival of interest at this time. Manet's admiration for Japanese art provides another source of inspiration for such intent focus on the details of everyday life.

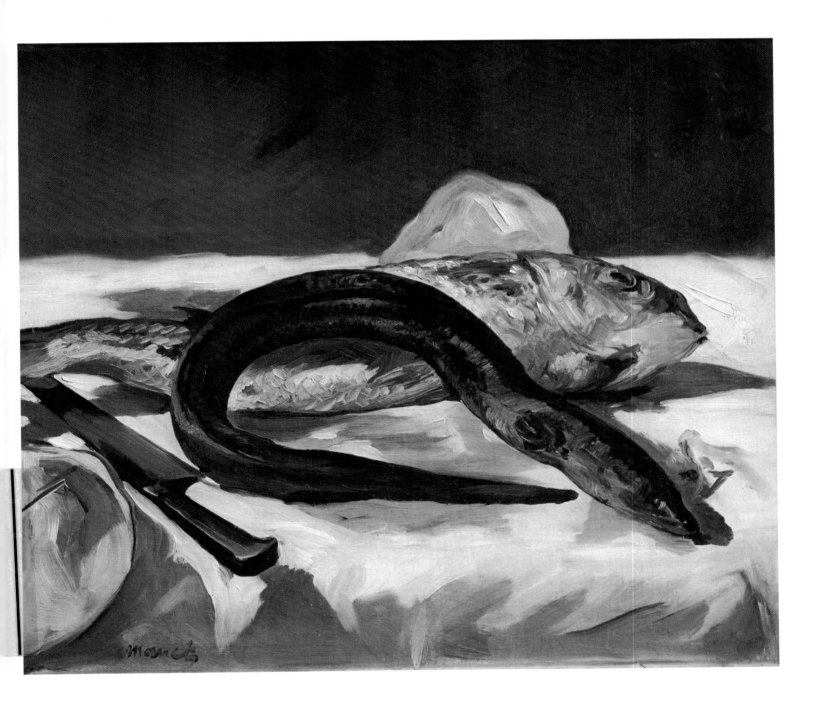

Peonies in a Vase

c.1864. Oil on canvas, 93 x 70 cm. Musée d'Orsay, Paris

During 1864 Manet painted a number of still lifes of peonies (compare Fig. 14), which grew in profusion at his country property at Gennevilliers. The variety he painted is the Chinese peony, which flowers in June and was introduced into Europe during the nineteenth century. It was regarded as a luxury flower, and was extremely popular in the drawing-rooms of the Second Empire. The rounded forms of the blooms with their exotic associations are in marked contrast to the simpler flowers Manet often painted in the last years of his life (see Plate 44).

The blooms are placed in a small porcelain vase, its shape complementing the fullness of the flowers. The cycle from bud to fallen petals is shown, and the painting shares with seventeenth-century Dutch still-life painting the ability to combine acute observation with the concept of *vanitas*, the insubstantiality of life.

Manet regarded the painting of still lifes as a pleasure and a relaxation, and he painted about twenty in all during 1864. His earliest essay in the genre, *The Plate of Oysters*, dates from two years before (National Gallery of Art, Washington DC). The subject of peonies provided him with an opportunity to study the range of colours of the blooms, cream, pink, and deep red, and the contrast between the forms of the blossoms and the elongated leaves, arranged with great simplicity and set against a dark background.

Fig. 14
Peonies

1864. Oil on canvas,
31 x 46 cm.
Musée d'Orsay, Paris

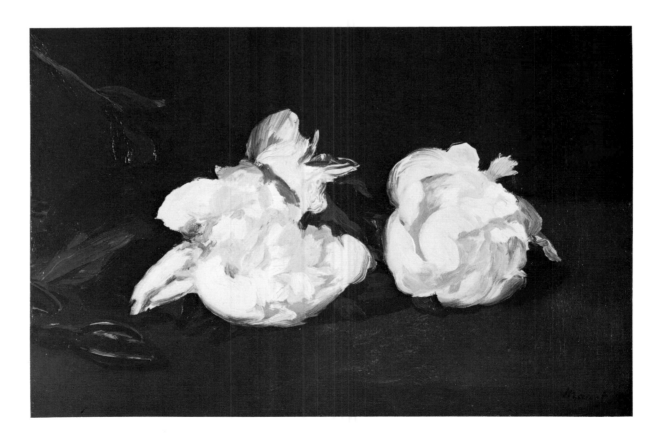

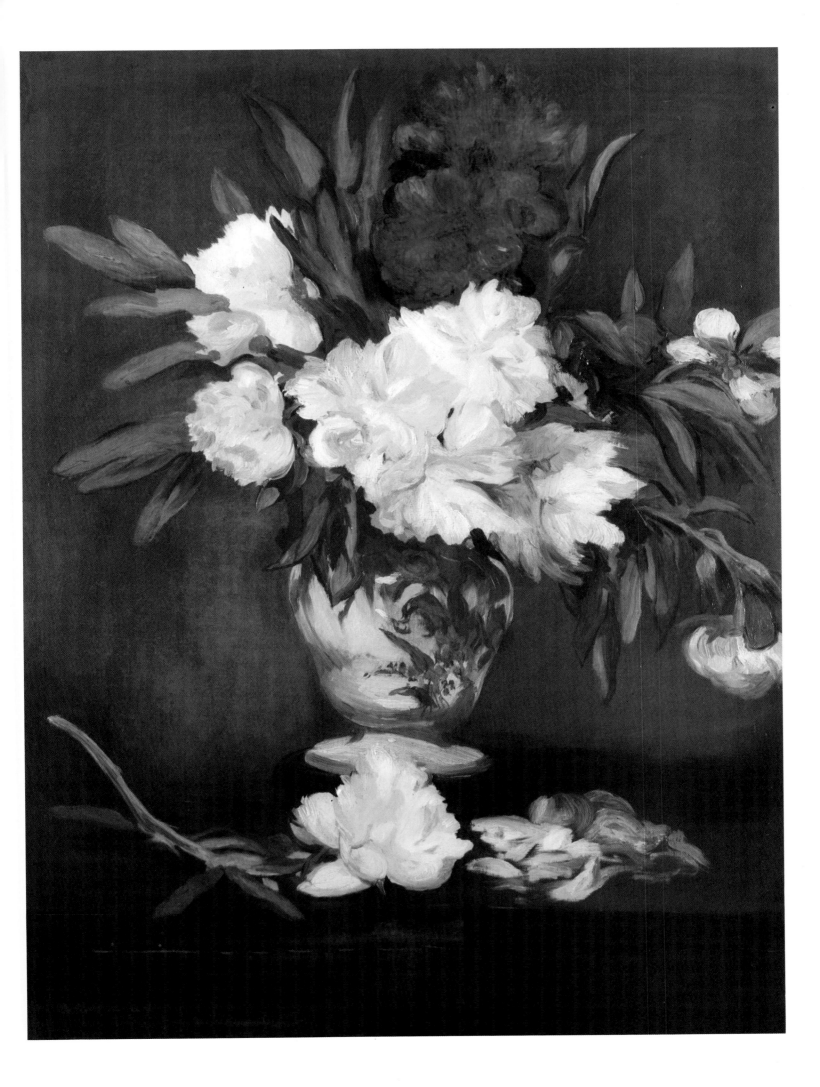

1864-5. Oil on canvas, 41 x 31 cm. Fanny Bryce Lehmer Fund, The Cincinnati Art Museum

Fig. 15
Racecourse at
Longchamp

1864. Gouache and water-
colour on paper,
22 x 56 cm.
Grenville L. Winthrop
Bequest, Courtesy of
the Fogg Art Museum,
Harvard University,
Cambridge, Mass

This painting is a fragment of a larger canvas, which Manet probably executed in 1864, adding the date 1865 later. The gouache of the *Racecourse at Longchamp* (Fig. 15) is thought to have been made after the painting, as a reproduction of it. This fragment, and the painting in the Cognacq Collection, Paris, both show a portion of the crowd lining the rails. The figure at the right of the canvas has been cut off near the top of the head, the carriage wheel at the left is cut off near its centre, and the wheel at the upper right only just appears.

As Harris pointed out (*Art Bulletin*, XLVIII, 1966), the viewpoint Manet selected in the complete painting is extremely unusual. He placed himself at the turning of the track, so that the horses are shown galloping up the track directly towards the spectator, instead of parallel to the picture plane (see Plate 26). The resultant sense of movement conveys more of the atmosphere and excitement of a race meeting than the more static conventional view.

The two women shown in the fragment are broadly painted, without superfluous detail, their attention focused on the action on the track. Manet's interest, unlike Degas's, was not in the racehorses, but in the race meeting as an aspect of *la vie moderne*.

The painting was formerly in the collection of the German impressionist painter Max Liebermann.

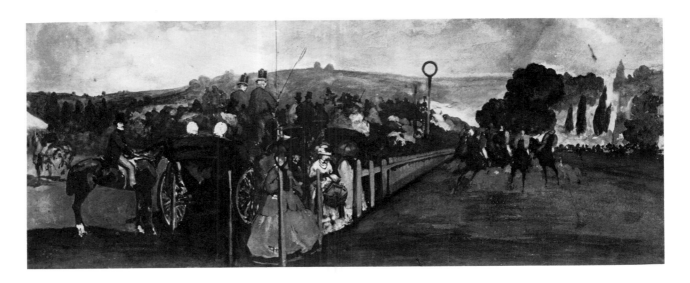

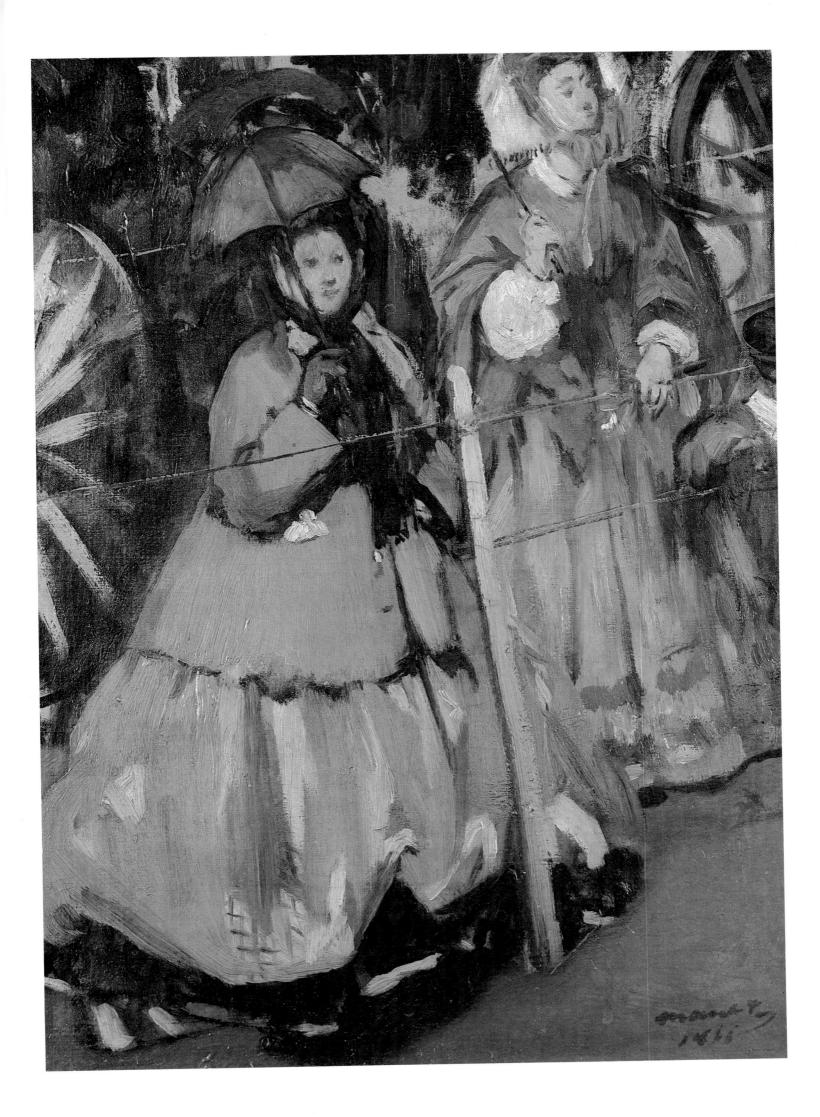

1865-6. Oil on canvas, 90 x 110 cm. Private collection

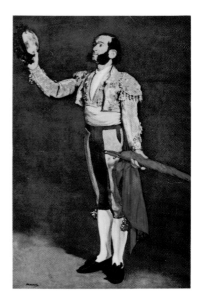

Fig. 16
Torero Saluting

1866. Oil on canvas,
171 x 113 cm.
Mrs H.O. Havemeyer
collection, The
Metropolitan Museum
of Art, New York

Manet visited Spain in September 1865. He met Théodore Duret (see Plate 17) in Madrid, and Duret recalled that they went to several bullfights where 'Manet made sketches which were later to serve as studies for his paintings'. Manet was extremely uncomfortable in Madrid, and Duret remembered, 'At the end of ten days, really starved and pining away, he was obliged to return [to Paris]'.

On his journey back, Manet wrote to Zacharie Astruc (see Fig. 19):

'I have seen a superb bullfight and intend when I get back to Paris to pin down on canvas the appearance of this motley crowd of people, without forgetting the dramatic part, the picador and horse knocked down and savaged by the bull's horns and the array of *chulos* (assistants) trying to draw the furious animal away.'

Manet painted three compositions showing the scene he described, two small and sketchy (Art Institute of Chicago and Collection Matsukata, Tokyo), and this larger version, as well as a life-size toreador saluting (Fig. 16) which he painted on his return to his Paris studio.

The dramatic action in the arena is watched by a crowd that is depicted as a blur of dark blobs of pigment, separated from the events in the ring by a high wall. The wall and the voyeuristic spectators were to recur in *The Execution of Maximilian* (Plate 14). Manet clearly understood the function of the bullfight as ritual, an enactment of life and death, and the struggle between victim and oppressor, with the possibility of a sudden change of these roles, so that here the taunting picador becomes the bull's victim.

The composition is related to Goya's *Tauromaquia* No.32, which Manet could have seen in the collection of his friend Philippe Burty, but his painting has a dispassionateness totally lacking in the Goya.

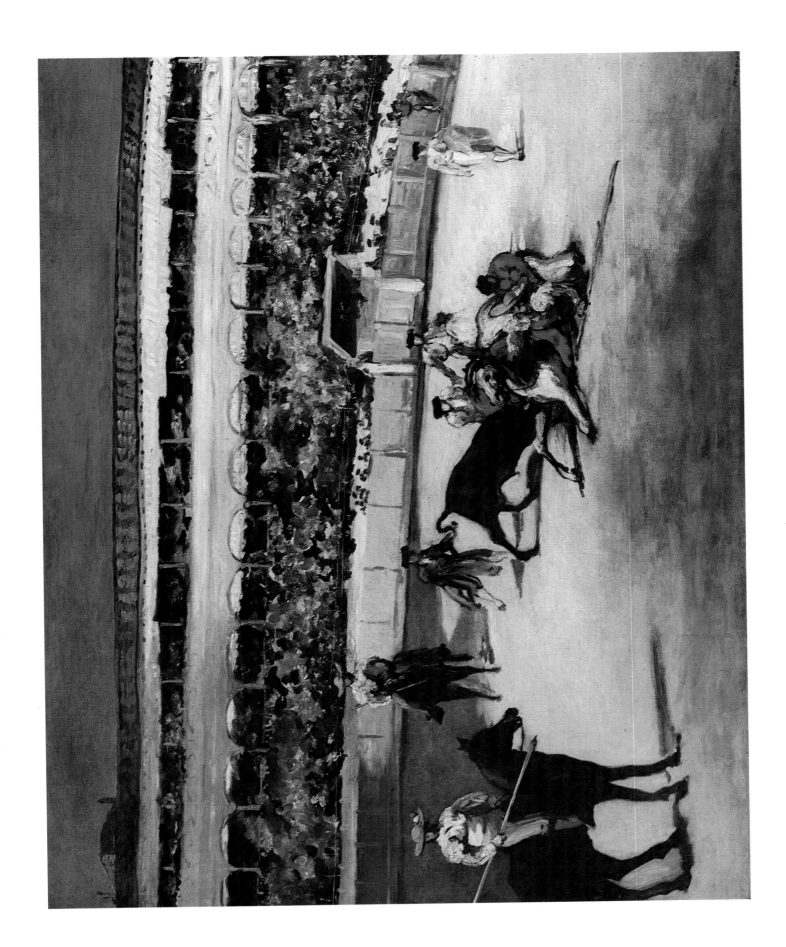

13 The Fifer

1866. Oil on canvas, 161 x 97 cm. Musée d'Orsay, Paris

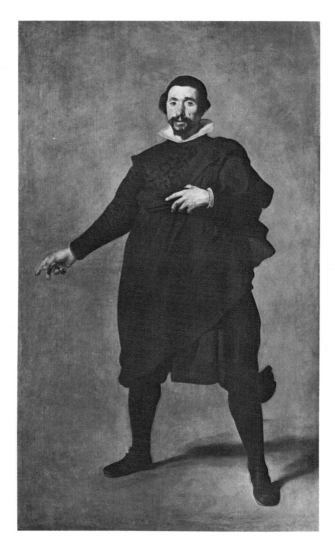

Fig. 17
Velázquez:
Pablillos de
Valladolid

c.1632. Oil on canvas,
209 x 123 cm.
Museo del Prado, Madrid

Emile Zola recognized that Manet's aim in painting *The Fifer* was to simplify. He praised the painting highly (see Introduction), but his assessment of the work's worth was not shared by the 1866 Salon jury, which rejected this painting and Manet's other submission, *The Tragic Actor*. Zola compared Manet's paintings to the accepted Salon entries, and noted that 'They break the wall'. The year after Manet's death Edmond Bazire wrote: 'This urchin, so jauntily painted, lively and gay, detaches himself from the dark background as if he were about to walk out of it.'

The figure was posed by a young fife-player, mascot of the *Garde Impériale*, and the face with its wide-set eyes and 'comma-like' eyebrows is reminiscent of Victorine Meurent's and Léon Koëlla's. The figure is frontally lit and stands in sharp distinction to the grey background. The stripe of the trouser legs in particular boldly outlines the body and separates it from its surroundings. The stripe's calligraphic quality, and the lack of internal modelling reveal the influence of Japanese prints on Manet.

Manet called Velázquez' *Pablillos de Vallodolid* (Fig. 17) 'perhaps the most astonishing painting ever done', and he particularly admired 'the way the figure is surrounded by nothing but air'. *The Fifer* reflects this admiration, and provides a synthesis of Spanish and Japanese elements and direct observation of a model.

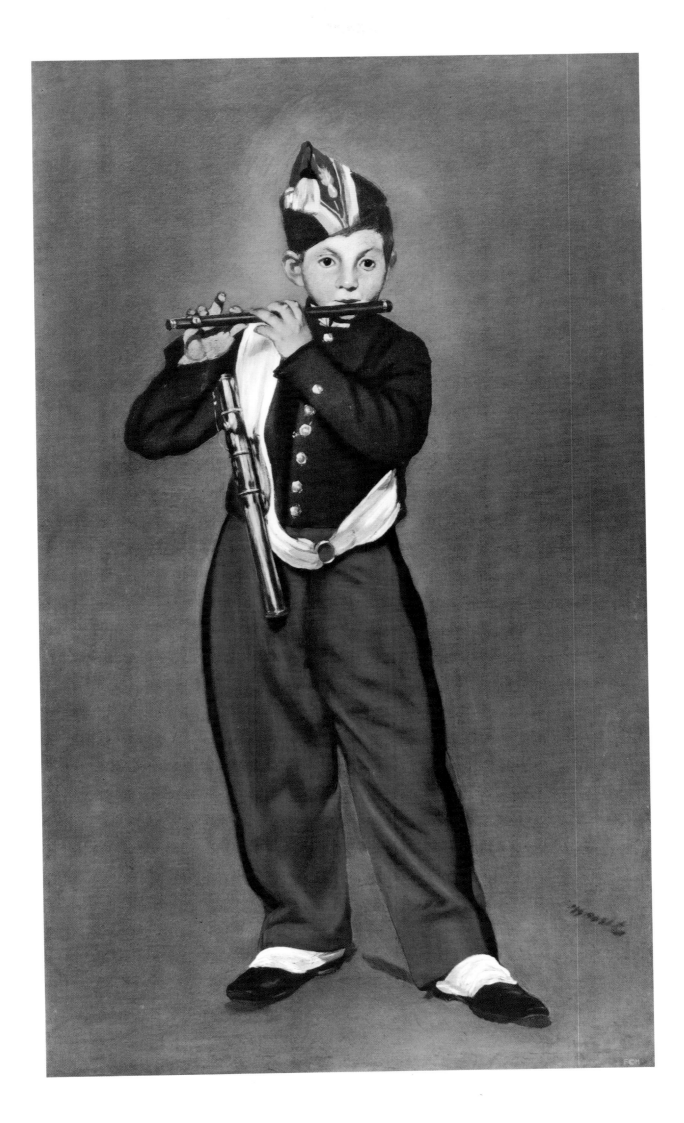

The Execution of the Emperor Maximilian of Mexico

1867-8. Oil on canvas, 252 x 305 cm. Städtische Kunsthalle, Mannheim

Fig. 18
Goya:
3 May 1808

1814. Oil on canvas,
266 x 345 cm.
Museo del Prado, Madrid

In April 1864 Napoleon III persuaded the Hapsburg Archduke Maximilian to accept the Mexican throne. Less than three years later, in February 1867, Napoleon III withdrew all French troops from Mexico, in breach of his agreement with Maximilian, leaving him totally vulnerable. Benito Juárez' liberal guerillas captured Maximilian and his generals Miguel Miramon and Tomás Mejía on 15 May and executed them near Querétaro on 19 June 1867. It is this date that Manet has signed on his canvas.

By early July *Le Figaro* had published an account of the execution which would have given Manet sufficient information to start the first version of this subject, now in the Museum of Fine Arts, Boston. The account described how the victims were dressed but gave no details about the soldiers' uniforms. Manet based the overall compositional scheme for his painting on Goya's *3 May 1808* (Fig. 18), setting the execution outdoors in semi-darkness, with the victims on the left and the firing-squad on the right. A similar composition was used again by Pablo Picasso in his *Massacre in Korea* (1951) to record another incident of contemporary history. Manet's painting differs markedly from Goya's in mood, being more detached and far less theatrical.

Probably in late September 1867 Manet began work on a second variant of the theme of the execution, of which four fragments now survive in the National Gallery, London (see Plate 15). Following this version came the small picture (50 x 60 cm.) now in the Ny Carlsberg Glyptotek, Copenhagen. The Mannheim picture is the definitive version of the four paintings. In it the execution is set in front of a high wall, over which peer a group of spectators, as if at a bullfight (see Plate 12). The soldiers wear uniforms which are very similar to those of French soldiers. Maximilian is shown in the centre of the three victims. Manet knew this to be factually incorrect, but suggests a parallel between the execution of the Emperor and the Crucifixion.

Manet was not able to exhibit the painting in France, where it was regarded as politically explosive, and it was first shown at a hotel in New York in 1879.

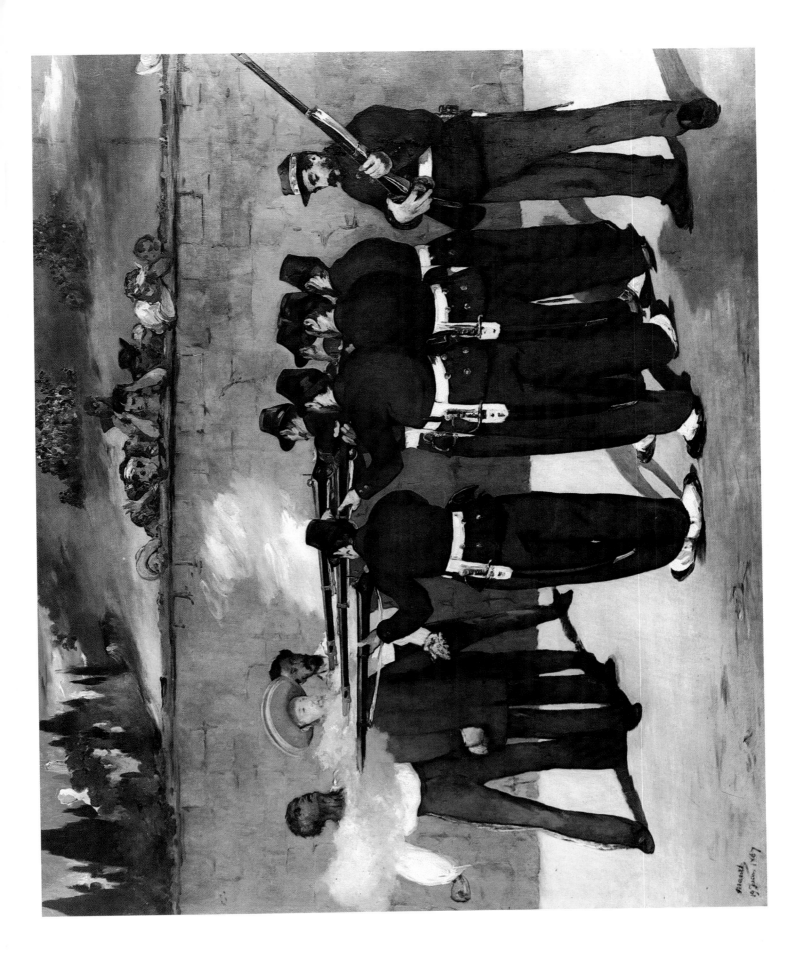

15 Soldier
(fragment of 'The Execution of Maximilian')

1867-8. Oil on canvas, 99 x 59 cm. National Gallery, London

This is one of four fragments of the second version of *The Execution of Maximilian* (Plate 14). The other three pieces show the firing-party, and the head and part of the body of General Miramón.

A Lochard photograph which was probably taken in Manet's studio soon after his death in 1883 shows the whole painting with the exception of Maximilian and General Mejía. Ambroise Vollard claimed that Ferdinand Leenhoff, Manet's brother-in-law, used the head of Maximilian to light a fire. The fragment of the soldier was probably the first portion cut off for sale, and it was purchased by Degas from the dealer Portier. Degas also acquired the other fragments from Vollard, and stuck them on to one canvas.

This version of the execution (the second of the four painted versions) would originally have been an extremely large painting in Manet's *oeuvre*, measuring approximately 270 x 300 cm. It was begun after Manet abandoned the Boston version of the subject, probably in the late summer of 1867. For this interpretation Manet used French soldiers as models for the firing-party, and Théodore Duret said that Manet's friend Commandant Lejosne brought soldiers from a nearby barracks to pose for him. Manet had by this time realized from a description in *Le Figaro* in August that the Mexican uniforms were similar to French uniforms, but his identification of the firing-squad with French soldiers may be interpreted as constituting an attack on Napoleon III's part in Maximilian's capture.

As an indication of Manet's working method it is interesting to note that he used a tracing of his lithograph of *The Execution of Maximilian* as the basis for a depiction of an event he had actually witnessed, in *The Barricade* (Fig. 2).

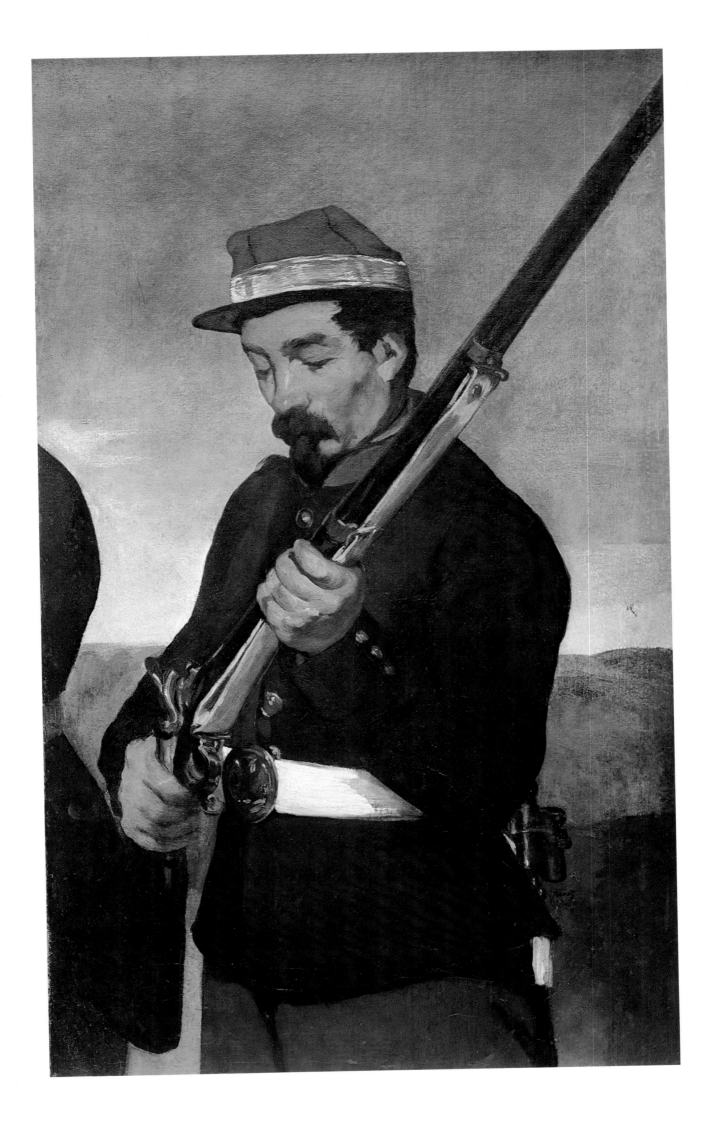

1867-8. Oil on canvas, 146 x 114 cm. Musée d'Orsay, Paris

Manet was introduced to Zola by the painter Antonin Guillemet in February 1866. Three months later Zola wrote an enthusiastic defence of Manet's work (*L'Evénement*, May 1866), which he later expanded into a long article (*Revue du XIXe Siècle*, January 1867). Manet painted this portrait as an expression of his thanks, and it was shown at the 1868 Salon.

The painting shows Zola seated at his desk, on which is to be seen a copy of the pamphlet on Manet. As in the *Portrait of Zacharie Astruc* (Fig. 19), the title on the book is also the artist's signature. On the wall above the desk is a lithograph, probably by Célestin Nanteuil, after Velázquez' *Drinkers*; a Japanese print by Kuniaki II, *The Wrestler Onaruto Nadaeman of Awa province*; and an etching and aquatint version of *Olympia* (Plate 7). Behind Zola is a Japanese screen, in the manner of Korin. The device of including an inset is common in Japanese wood-block prints of the 1840s and 1850s, where the subject enclosed in the cartouche is often intended to represent an oil-painting.

As Reff has noted (*Burlington Magazine*, January 1975), the contrasting figures of Olympia, the wrestler, and Bacchus (in the Velázquez) look directly at Zola, who does not return their gaze. The importance of the objects surrounding the figure, attributes supposedly informing one about Zola, encourages the belief that they are expressions of Manet's own interests rather than Zola's, and Odilon Redon observed penetratingly in his Salon review (*La Gironde*, 9 June 1868), 'It is rather a still life, so to speak, than the expression of a human being'.

Zola himself was not entirely delighted with his portrait, which Manet presented to him, and Huysmans noticed that he had relegated the painting to an antechamber of his home.

Fig. 19
Portrait of Zacharie Astruc

1864. Oil on canvas,
90 x 116 cm.
Kunsthalle, Bremen

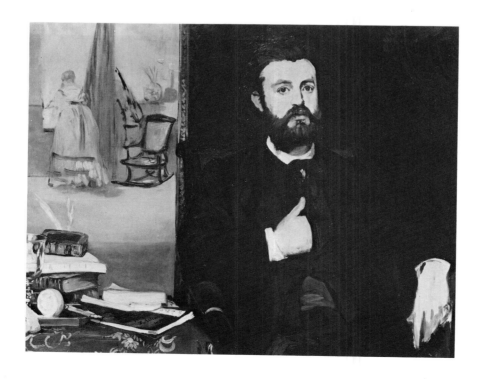

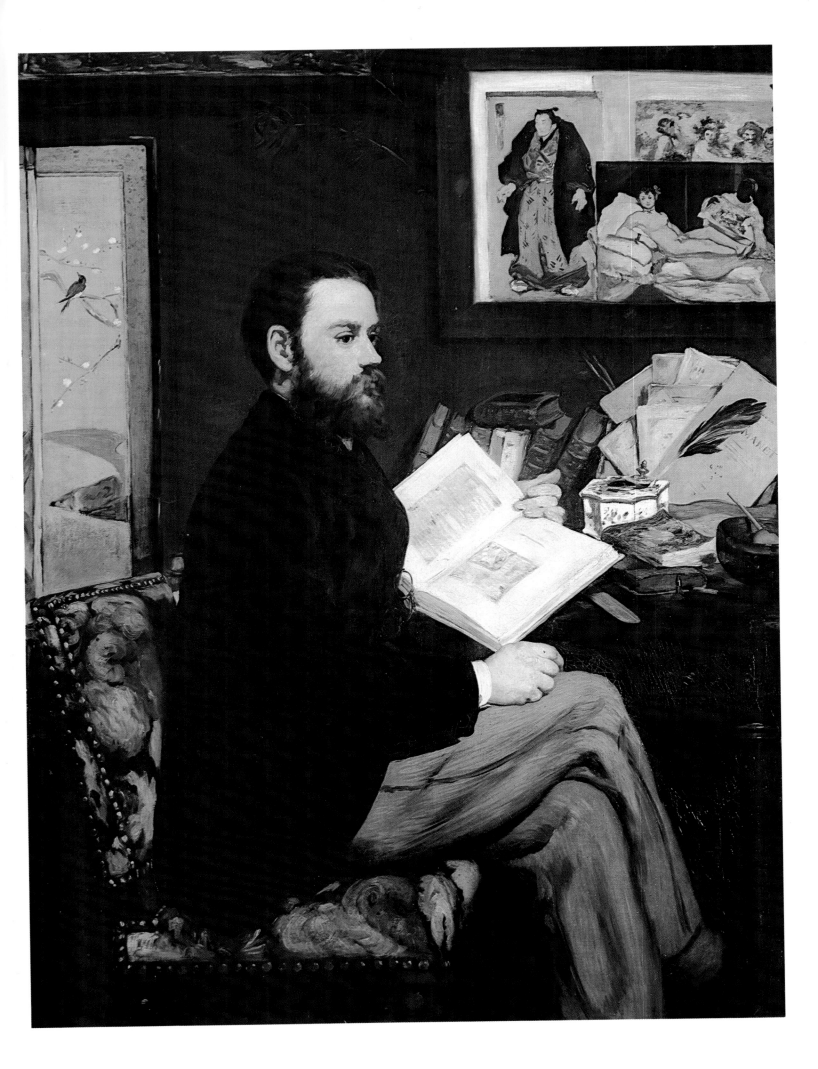

Portrait of Théodore Duret

1868. Oil on canvas, 43 x 35 cm. Musée du Petit Palais, Paris

Manet met Théodore Duret, then a businessman, later a journalist and critic, in Madrid in the late summer of 1865. In his biography of Manet, Duret recalled how they explored Madrid together:

'Naturally we went every day to the Prado and spent a considerable time before the paintings of Velázquez. At this time Madrid preserved its old picturesque appearance; in the Calle de Seville in the centre of the city there were still a number of cafés in the old houses which provided a rendezvous for people connected with bull-fighting. We went to several bullfights . . . We also went to Toledo to see the cathedral and the El Greco paintings.'

In 1867 Duret published *Les Peintres français en 1867*, in which he discussed Manet's work. When Manet presented him with this portrait as an expression of gratitude, Duret responded by sending him a case of cognac and requesting that he either remove his signature from the light area of the painting, or sign invisibly in the shadow. Manet reacted by signing his name upside down, with Duret's cane pointing to it. The inversion of the signature makes it more conspicuous since it creates a puzzle which the viewer feels obliged to solve before looking at the figure of Duret himself.

Manet added the still life to the portrait almost as an afterthought, and Mauner (*Manet, Peintre-Philosophe*, 1975) suggests that the book apparently discarded, is Duret's volume on the French painters, since his remarks on Manet were tentative and qualified.

The life-size *Woman with a Parrot* (Fig. 20), accepted at the 1868 Salon, shares with this small portrait a still-life group with a glass and a lemon, and the undifferentiated background which serves to emphasize the outline of the figure.

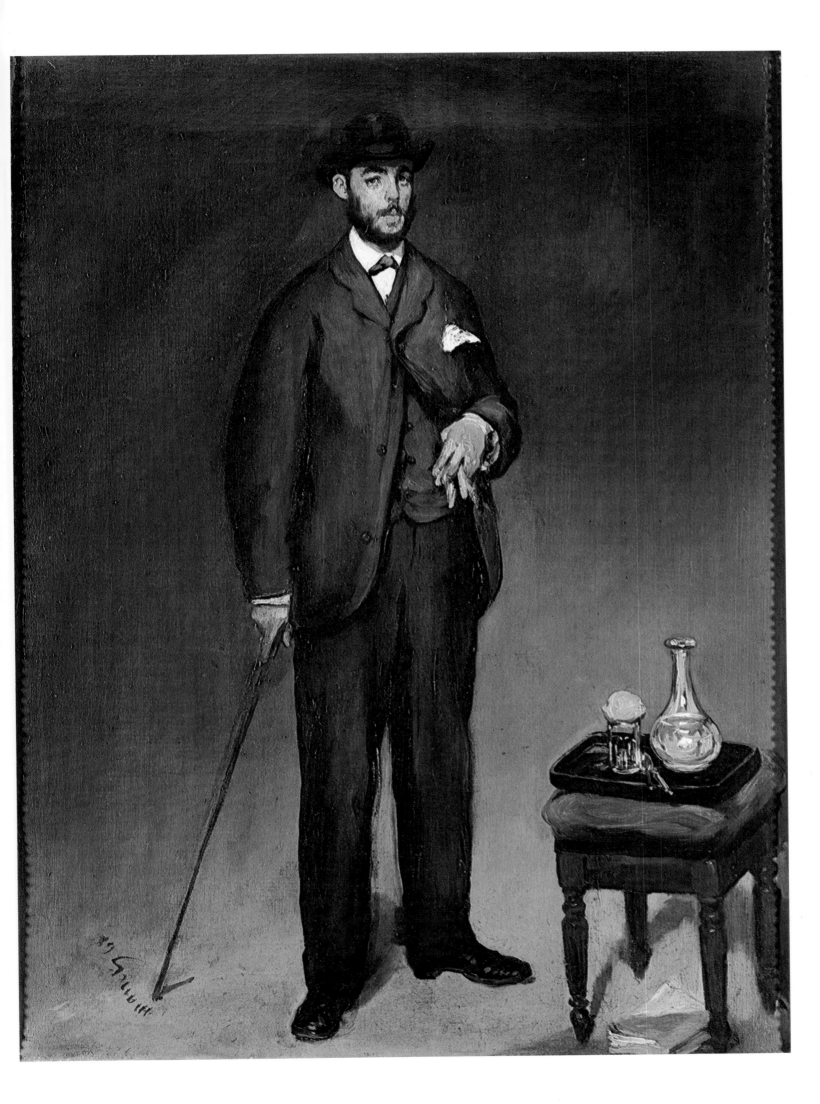

The Balcony

1868. Oil on canvas, 170 x 125 cm. Musée d'Orsay, Paris

This canvas was exhibited at the 1869 Salon, where critical reaction to it as a depiction of *la vie moderne* masked its relation to Goya's *Majas on a Balcony*. The painting shows Berthe Morisot, whom Manet painted on several occasions (see, for example, Plates 22 and 25), seated in the foreground. Next to her is the violinist Fanny Claus, and behind the women is the painter Antonin Guillemet, who exhibited *Village on the Banks of the Seine* at the same Salon. Léon Koëlla appears in the background carrying a coffee service.

Berthe Morisot had met Manet through Fantin-Latour, and the Manet and Morisot families soon became close friends. Madame Manet wrote to her daughter Edma:

'Tomorrow we are going to see Manet's painting. Antonin [Guillemet] says that he made him pose fifteen times to no effect and that Mademoiselle Claus is atrocious. But both of them, tired of posing on their feet, say to him: "It's perfect – there is nothing more to be done over"'.

The figures are harshly frontally lit and are detached both from each other and from the spectator, frozen in rigid poses. Manet employs the ironwork of the balcony and the louvred shutters as flattening devices, compressing the apparent depth of the balcony and the interior beyond it, and emphasizing the two-dimensionality of the picture surface. He thereby establishes pictorial tensions and raises queries about the relationship between the spatial possibilities of a painting, and the space of the world outside the painting. Such questions are increasingly frequently posed in Manet's later work, culminating in *A Bar at the Folies-Bergére* (Plate 46).

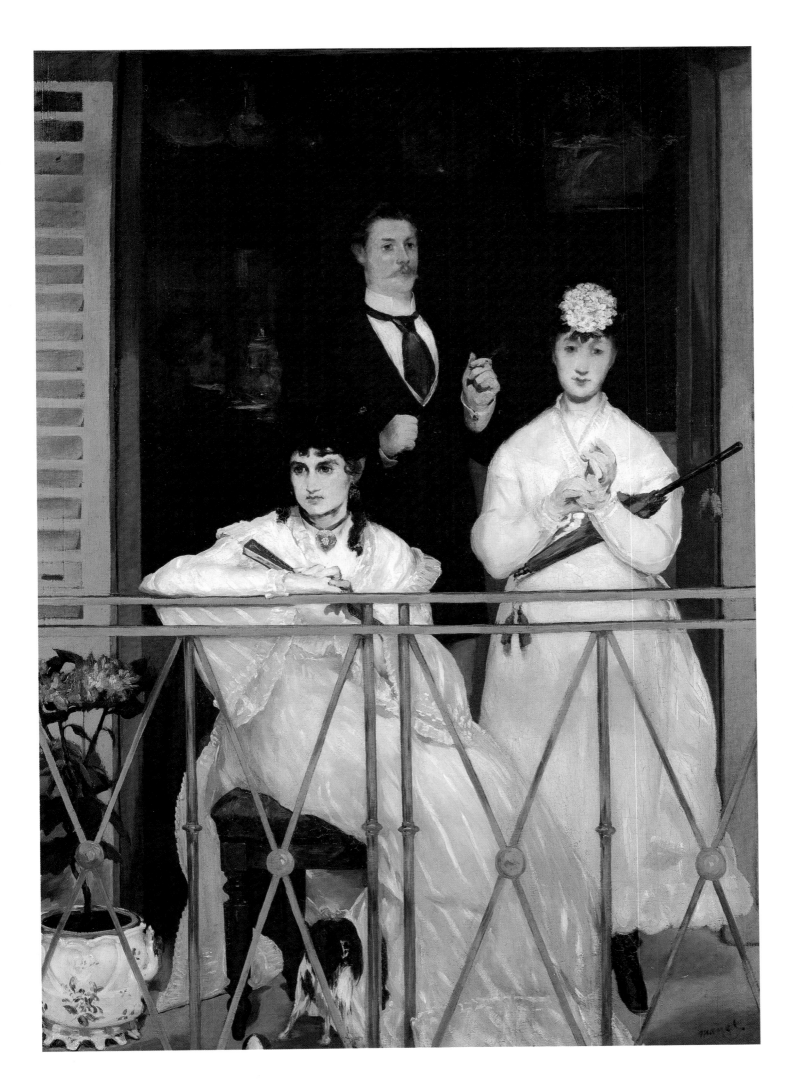

1868. Oil on canvas, 120 x 153 cm. Bayerische Staatsgemäldesammlungen, (Neue Pinakothek), Munich

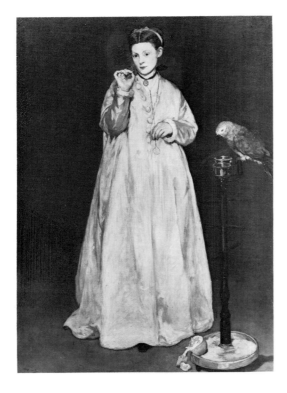

Fig. 20
Woman with a Parrot

1866. Oil on canvas,
185 x 132 cm.
E. Davis collection, The
Metropolitan Museum of
Art, New York

This painting was begun during the summer of 1868 at Boulogne-sur-Mer, where the Manets rented a house. An oil sketch, now lost, was its basis, for which Claude Monet was allegedly the male model. This painting was completed in Manet's Paris studio, and was accepted at the 1869 Salon. The male figure on the right is believed to be Auguste Rousselin, a painter whom Manet had met at Couture's studio, and the central figure is Léon Koëlla.

It has been observed by Bradford R. Collins (*Art Journal*, Winter 1978/9) that the painting may be seen as an *hommage* to Baudelaire, who died in 1867. Baudelaire wrote: 'The distinguishing characteristic of the dandy's beauty consists above all in an air of coldness . . .', and Léon Koëlla's air of *hauteur* in this painting qualifies him as a dandy. Behind him, painted with less definition, in broader strokes, are two distinct types of still-life arrangement, each corresponding, not to the figure next to it, but to the opposite figure. On the left are a helmet, a musket, and a sword, objects associated with Second Empire romanticism and with Manet's past. (Courbet had used a dagger in *The Painter's Studio* (Fig. 12) to represent his earlier romantic phase.) The man smoking on the right is the epitome of the romantic.

Baudelaire said that Manet was marked by Romanticism from birth. However, he balanced his past with his concern for the new and immediate. On the right of the canvas is a naturalistic still life, arranged and painted in a manner reminiscent of Chardin, and the maid holding the coffee pot is a Chardin type.

The assemblage of objects invites an interpretation of their symbolism. The sword was associated with Léon Koëlla in other portraits, as a symbol of manhood, but is also regarded in Japan as the soul of the samurai (the counterpart of the modern European hero, the dandy). The black cat curled up next to the sword had been used by cartoonists as Manet's trademark since *Olympia* (Plate 7), and was seen as a phallic symbol. The peeled lemon, used elsewhere by Manet (for example in *Woman with a Parrot*, (Fig. 20), is a *vanitas* symbol frequently found in seventeenth-century Dutch art.

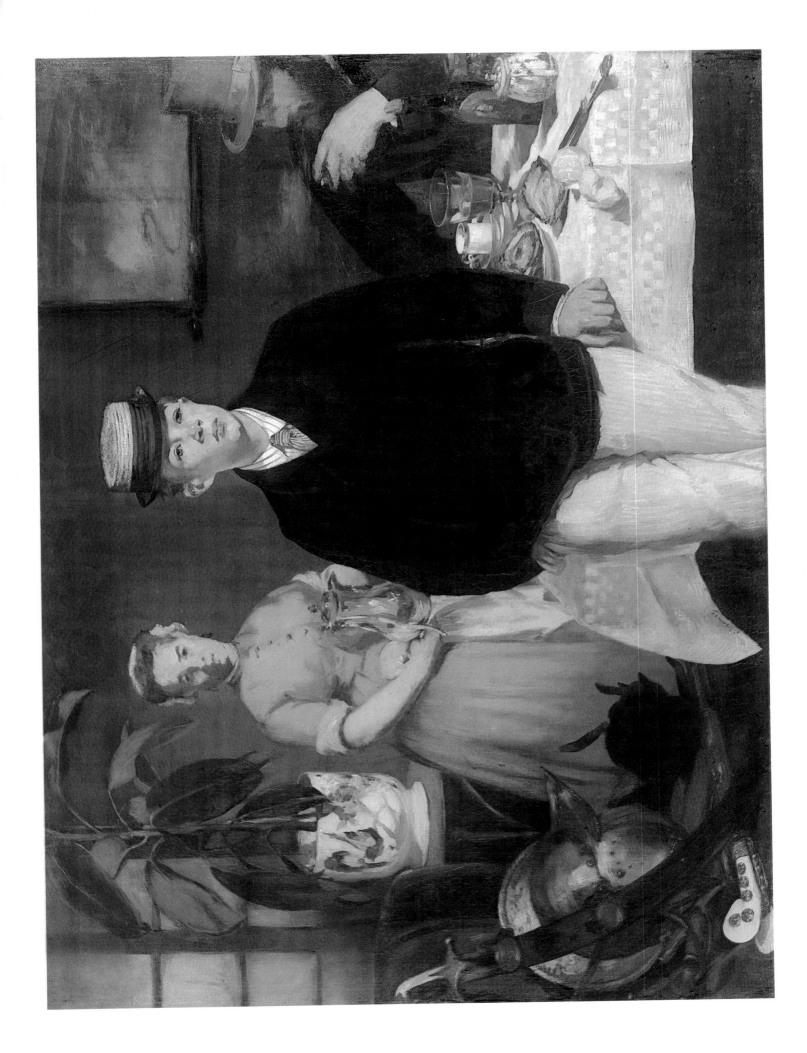

Beach at Boulogne-sur-Mer

1869. Oil on canvas, 33 x 65 cm. From the collection of Mr and Mrs Paul Mellon, Upperville, Virginia

In spite of Tabarant's claim that Manet painted this view of the beach *en plein air* and *sur le motif*, preparatory sketches indicate that this was not the case. It does, however, mark the beginning of the phase in Manet's career which brought him closest to the Impressionists, and which culminated in his paintings executed at Argenteuil or Gennevilliers in the summer of 1874, often in the company of Monet (see Plates 29, 30, 31, and Fig. 26).

The painting shows an assemblage of disparate elements set against horizontal bands of beach, sea, and sky. Individuals or small groups are all equally weighted at the expense of the unity of the entire composition, and the relationship in scale of the different clusters of figures often appears awkward. In novels of the period, such as Flaubert's *Sentimental Education* (published in 1869, the year this painting was executed), a similar tendency to give equal weight to all aspects of the novel, small details being ascribed equal significance with more momentous happenings, has been noted and regarded as one of the hallmarks of the realist novel. Manet's composition is a parallel to this literary development, and since Manet's position in literary circles was unique among his contemporaries, one may safely assume him to have been conversant with the aims and intentions of the novelists of the day.

Each of the preparatory sketches for this painting records a complete visual experience, and the final work, as Alain de Leiris has pointed out (*Gazette des Beaux-Arts*, January 1961), reflects the composite character of the artist's initial visual perception of the scene.

1869. Oil on canvas, 61 x 74 cm. Musée d'Orsay, Paris

This painting shows Madame Manet, née Suzanne Leenhoff, being read to by Léon Koëlla. Manet's wife was Dutch, two years his senior, and an excellent musician (Fig. 21 shows her at her piano). She had been employed by M. Manet *père* to give Edouard and his brother Eugène piano lessons at the family's home in the rue des Petits Augustins. After a relationship lasting more than ten years, Manet finally married Suzanne in Holland in 1863, after his father's death. Léon Koëlla was Suzanne's son, born in 1852. His father was almost certainly Manet, but he was presented as Suzanne's younger brother.

The painting is a 'symphony in white', as Paul Mantz had described Whistler's *The White Girl* (National Gallery of Art, Washington DC) in 1863. Suzanne wears a white dress and is set on a white sofa against the white window drapes. The jet beads around her neck and her black belt form a contrast to the interplay of white, as does the dark background area which frames the profile view of Léon's head. Léon's body is cut off entirely at the right edge of the canvas, so that only his left forearm and hands are visible, and on the left the large indoor plant is equally severely cropped.

The tradition of tonal painting was an established one in French art, for example in the work of Jean Baptiste Oudry (1686-1755). In his continuing quest for a balance between old and new, Manet adapted this tradition to show a scene of *la vie moderne*.

Fig. 21
Madame Edouard Manet at the Piano

1868. Oil on canvas,
38 x 46.5 cm.
Musée d'Orsay, Paris

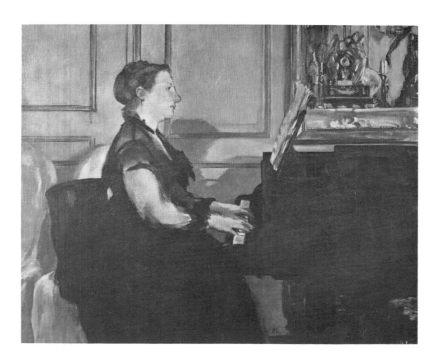

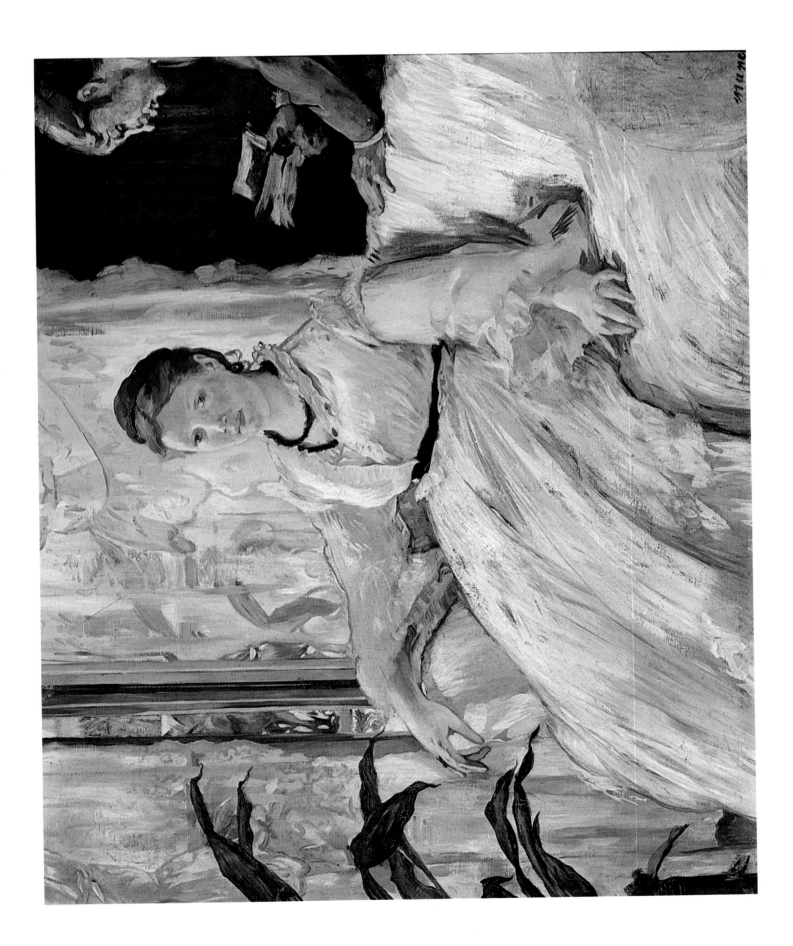

1869-70. Oil on canvas, 148 x 111 cm. Rhode Island School of Design, Museum of Art, Providence, Rhode Island

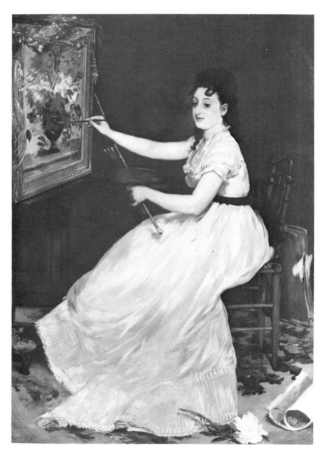

Fig. 22
Portrait of Eva
Gonzalès

1870. Oil on canvas,
191 x 133 cm.
National Gallery, London

Berthe Morisot is shown reclining on a plum-coloured sofa in Manet's studio, a Japanese triptych visible on the wall behind her. The painting was shown at the 1873 Salon, and since Madame Morisot felt it was improper for a young woman of good family to be shown in such a pose, Berthe Morisot was not identified in the Salon catalogue. Anne Coffin Hanson's view (*Manet and the Modern Tradition*, 1977) that 'no allegorical meaning is intended by the title "Repose" or "Rest", although this popular title was undoubtedly used by other artist for such a purpose' may be questioned. The pose, with one leg tucked under the body and the other thrust out, is extremely relaxed and informal, and the face is painted with a softness and blurring of definition which contrasts markedly with the portrait of Berthe in *The Balcony* (Plate 18). Théodore de Banville described the work as 'an engaging portrait which holds our attention and which imposes itself on our imagination by an intense character of *modernity*'.

At the same time as he painted this portrait, Manet was working on his *Portrait of Eva Gonzalès* (Fig. 22), causing Berthe to remark with some pique:

'We spent Thursday evening at Manet's. . . . As of now, all his admiration is concentrated on Mademoiselle Gonzalès, but her portrait does not progress; he says that he is at the fortieth sitting and that the head is again effaced. He is the first to laugh about it . . .'

Some days later she wrote: 'To my great surprise and satisfaction, I received the highest praise; it seems that what I do is decidedly better than Eva Gonzalès'.

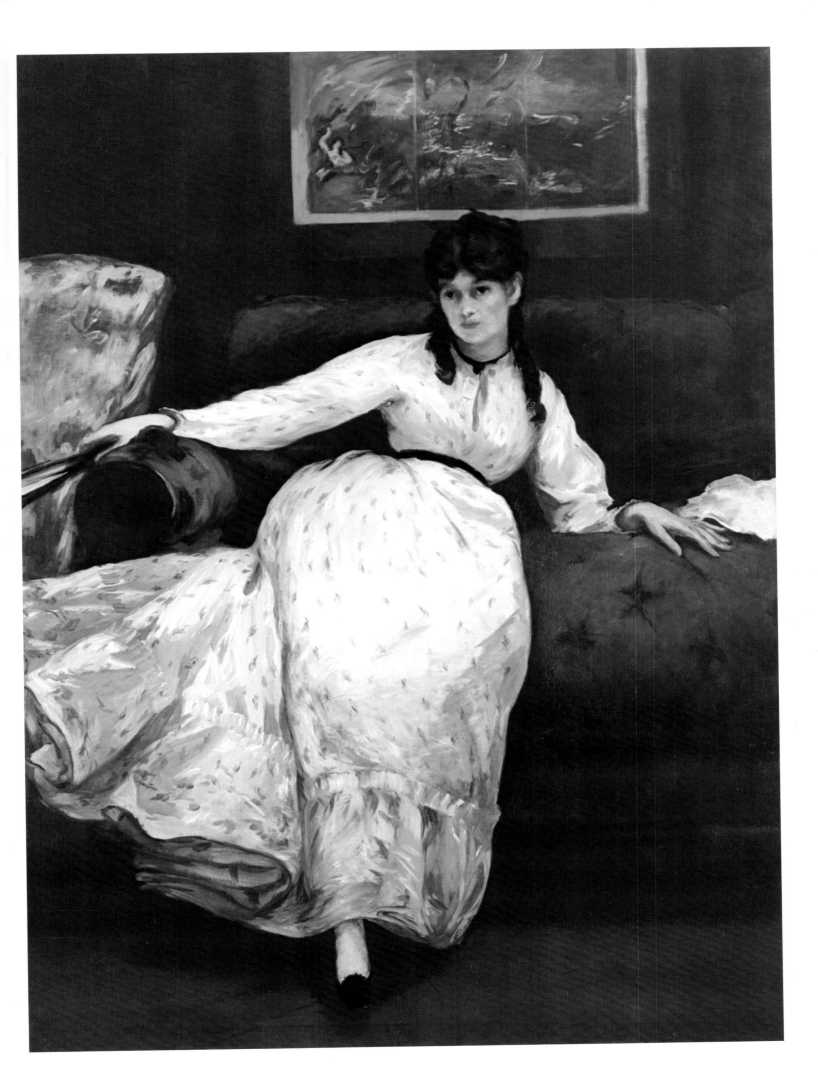

The Harbour at Bordeaux

1871. Oil on canvas, 65 x 100 cm. Foundation E.G. Bührle collection, Zurich

In February 1871 Manet left Paris and rejoined his family, who had taken refuge with friends at Oloron in south-west France during the Franco-Prussian War. He was depressed and unwell, and had written to Suzanne shortly before leaving:

'We were dying of hunger and even now we are suffering very much. We are all as thin as laths; I, myself, have been unwell for several days as a result of getting overtired and from bad food.'

After a few days with his family, Manet decided that they had already taken too much advantage of their friends' kindness, and, not wanting to return to Paris, determined to take a house at Arcachon on the Atlantic for a month. He went to Bordeaux to make the necessary arrangements, and from the first-floor window of a café on the Quai des Chartrons he painted this view of the harbour, with the Cathedral of Saint-André in the background.

Manet depicted the forest of masts in the harbour, painting sketchily and without concern for precise detail. The verticals of the masts are related to the towers of the cathedral beyond. A sense of Manet's detachment from the activity he recorded is conveyed by the fact that all the figures have their backs to the spectator. Unlike *The Departure of the Folkestone Boat* (Fig. 23), painted two years earlier, where the fashionably dressed crowd on the quay is the real subject of the painting, here the figures are used to give a sense of scale to the anchored boats and to direct the viewer's attention towards them. Antonin Proust recalled:

'Gambetta went into ecstasies over this picture, which reminded him of the last hours of the National Defence. Manet wanted to make him a present of it. "Thank you, my friend," said Gambetta, "but I'm not rich enough to buy it, and I couldn't accept it as a gift."'

Fig. 23
The Departure of
the Folkestone
Boat

1869. Oil on canvas,
60 x 73.5 cm.
Tyson collection,
Philadelphia Museum
of Art

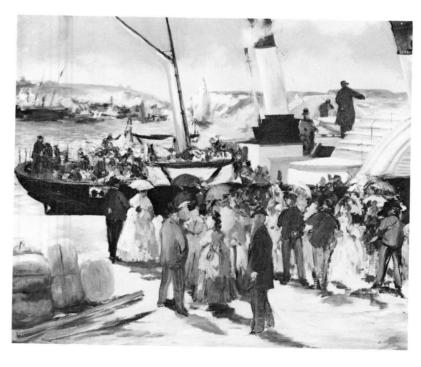

24 Nude

c.1872. Oil on canvas, 60 x 49 cm. Musée d'Orsay, Paris

Manet had not painted a female nude since *Olympia* (Plate 7) when in 1872 this dark-haired woman posed for him in his rue de Saint Pétersbourg studio. Her identity is not known. The thin, rather cursory application of pigment suggests that the painting was rapidly executed, perhaps even in a single sitting, unlike many of Manet's portraits which made great demands on his models and required numerous sittings.

The model's dark, somewhat Spanish appearance has been emphasized by the black velvet ribbon and cameo at her throat, while her shoulders and breasts are framed by the black shawl she holds loosely about herself. Her brooding expression appears to have interested Manet far more than her body, which is painted as an almost flat area, with the breasts indicated by perfunctory semicircular grey brushtrokes creating shadow areas. In contrast to Renoir, for example, Manet was not interested in evoking the sensuousness of flesh in his paintings, and he preferred to paint striking-looking women rather than conventionally pretty models.

The deep brown background to the painting is similar to that of *Repose* (Plate 22), with the randomness of the scarlet marks on the left of the canvas emphasizing the work's lack of finish.

Berthe Morisot

1872. Oil on canvas, 55 x 38 cm. Private collection

Manet painted Berthe Morisot shortly after her return from a visit to Madrid, where, with an introduction from Manet, she had sought out Zacharie Astruc (Fig. 19). She wrote to her mother:

'I have found the handsome Astruc; he has put himself entirely at our disposal for visiting the city, which he knows well. We shall content ourselves with him; he has the advantage of speaking French, and he is no more commonplace than anyone else. I have no intention of exerting myself to see anything but paintings.'

Berthe Morisot's black costume and elaborate hat perched high on her head give her something of the look of a Goya figure, while the flattening of forms by the use of black to produce a two-dimensional pattern-like effect on either side of her face is a Japanese convention. But transcending all such references is the face of Berthe herself, looking directly at the viewer, candidly and with a hint of amusement. Her head emerges from the flatness of the black surrounding areas, which in their turn contrast with the light, undifferentiated background. The portrait is lit from one side, producing a strong contrast between light and shadow and a sense of rounded form not common in Manet's portraits, so often frontally lit.

Manet admired Berthe Morisot's work, and enjoyed a close, if sometimes stormy, friendship with her. Berthe's marriage to Manet's brother Eugène was being discussed at about this time. Madame Morisot was not enthusiastic about the proposed match, considering Eugène to be 'three-quarters mad', but believing that 'It's better to marry and make some sacrifices than remain in a position that is really not one thing or the other . . .' Berthe was won over and married Eugène Manet in December 1874.

1872. Oil on canvas, 73 x 92 cm. Private collection

Manet was commissioned to paint this work by a sportsman and *amateur*, Monsieur Barret. He postponed starting the painting until after his return from a visit to his wife's parents in Holland in the summer of 1872. He finished the painting, as he advised M. Barret, on 21 October, and on the following day he acknowledged receipt of 3,000 francs.

Although he visited the racecourse and made many preliminary drawings (now in the Cabinet des Dessins, Musée du Louvre, Paris), Manet chose to copy the galloping horses from English sporting prints he had in his studio. He told Berthe Morisot: 'Being unused to painting horses, I've copied the people who know best how to do them'. The result is an uneasy relationship between the horses and the spectators, with none of the sense of movement of the earlier *Racecourse at Longchamp* (Fig. 15). The painting reveals a composite vision similar to that of the *Beach at Boulogne-sur-Mer* (Plate 20). It is possible that some of the figures, in particular the couple standing directly behind the leading horse's head, have a source in the illustrated journals and publications such as *Les Français peints par eux-mêmes*, which Hanson has shown Manet drew on (*Museum Studies, Art Institute of Chicago*, III, 1969).

In the bottom right-hand corner of the canvas is a portrait of Degas, a gesture of salute from Manet to his friend the master of racehorse and racecourse paintings (Fig. 24).

Fig. 24
Edgar Degas: Carriage at the Races

c.1870-2. Oil on canvas, 34 x 54 cm. Arthur Gordon Tompkins Residuary Fund. Courtesy of Museum of Fine Arts, Boston

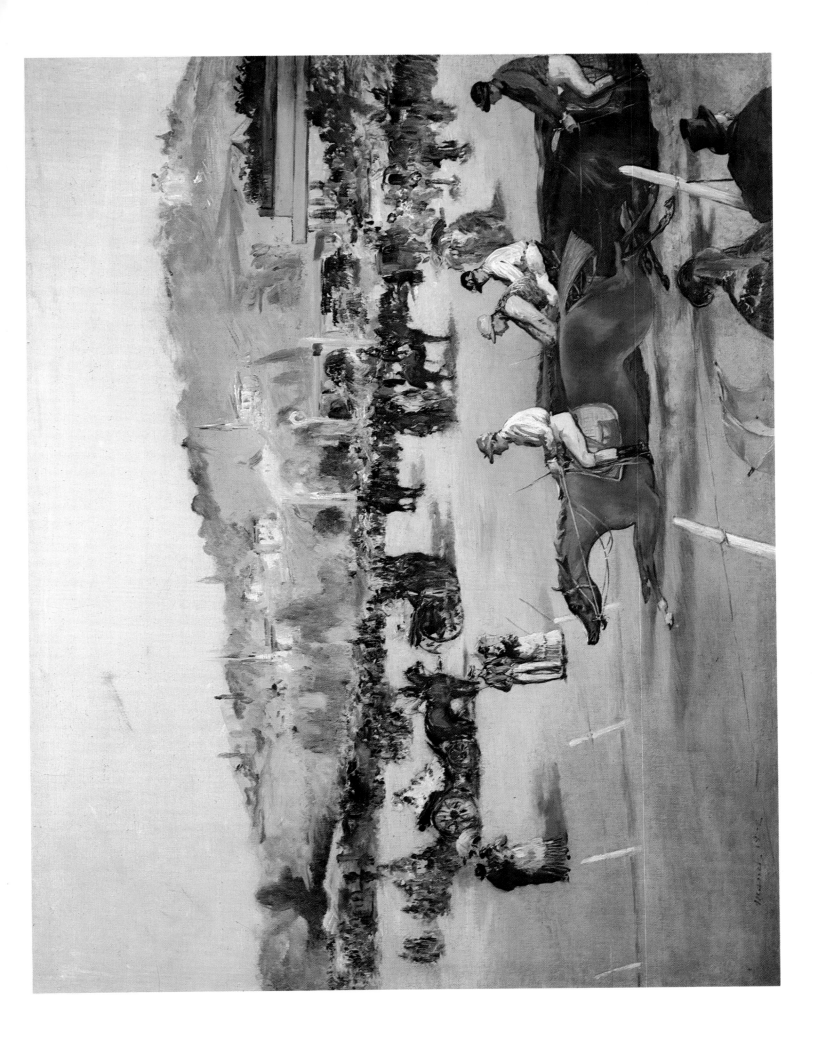

c.1873. Oil on canvas, 56 x 46 cm. Oskar Reinhart collection 'Am Römerholz', Winterthur

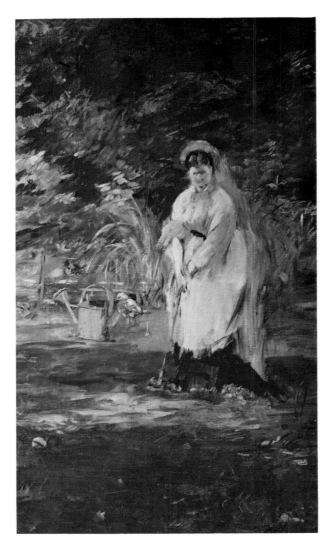

Fig. 25
Detail of 'The
Game of Croquet'

1873. Oil on canvas,
72 x 106 cm.
Städelsches Kunstinstitut,
Frankfurt

Marguerite de Conflans came from a family which had close ties with the Manets. She was frequently invited to attend Madame Manet's musical parties, and her appearance so attracted Manet that he painted several portraits of her. In one of these (Smith College, Northampton, Mass.), she is shown in a very similar pose to that employed here, her head resting on her right hand, looking directly at the spectator. In all the portraits she is dressed in ball dresses of light-coloured fabric, in this example she wears a hood of white diaphanous material. Her appearance was striking, not conventionally pretty, with black eyes, heavy eyebrows, and long black hair.

After the 1860s, many of Manet's models came from the *haute bourgeoisie*, and in the case of Marguerite de Conflans this made it necessary for Manet to paint her at her own home, since a *fille de bonne famille* could not go alone to an artist's studio (*pace* Berthe Morisot – see Plate 22). Manet has set his model against a background of pure black, emphasizing her eyes and brows, and giving no indication of the specific details of her surroundings.

The pigment is sketchily applied, and detail is sacrificed to achieve an overall effect in an impressionistic manner, as in the contemporary *Game of Croquet* (Fig. 25), but without the concern for light and colour evinced by Monet or Renoir. The painting was retouched at some time after its completion.

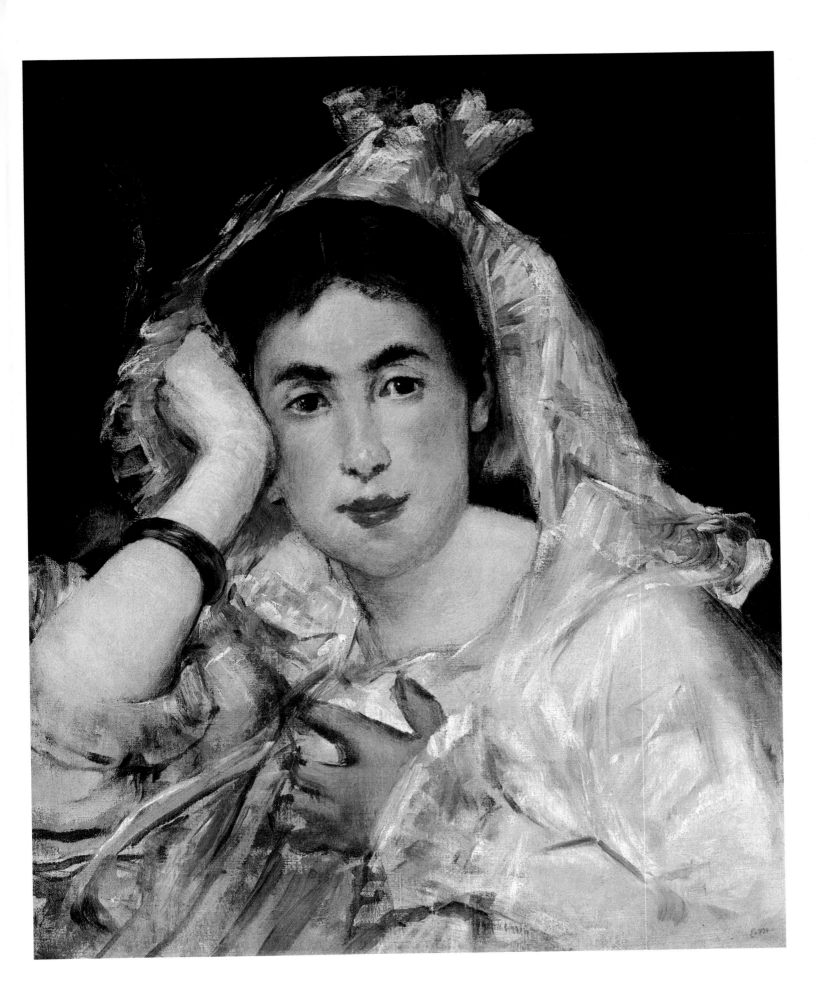

The Railway

1873. Oil on canvas, 93 x 114 cm. Collection H.O. Havemeyer bequest, National Gallery of Art, Washington DC

This painting was accepted by the 1874 Salon jury, and was the largest canvas Manet had hitherto painted in great part *en plein air*. Manet's studio in the rue de Saint-Pétersbourg was so close to the Pont de l'Europe, the railway bridge outside the Gare St Lazare, that Fervacques wrote in December 1873 (*Le Figaro*):

'. . . the air is filled with whirling plumes of white smoke. The ground is continually shaken by the trains rumbling past and trembles under one's feet like the deck of a ship.'

The background of the painting shows the smoke-laden air and, at the right-hand edge of the canvas, the Pont de l'Europe. An iron grating separates the figures in the foreground from the railway. The models were Victorine Meurent, newly returned from America, and the daughter of the painter Alphonse Hirsch, in whose garden Manet painted this section of the canvas.

Victorine looks up from her book, her face devoid of expression. She is completely detached, physically and psychologically, from the little girl with her back towards the viewer. The iron railings compress the picture space and push the figures so far forward that it is only the indifference of Victorine's gaze that prevents them seeming to invade the spectator's own physical space.

Amidst the storm of hostile criticism that greeted this painting, one friendly voice which emerged was that of the poet Stéphane Mallarmé (see Plate 33). Furthermore, the year after Manet's death, Jacques de Biez wrote:

'. . . You have the picture [*The Railway*] mirrored in your memory, and you ask me, "Where the devil *is* the railway in this picture of a railway?" Where is it? Good heavens! There, there where that modern grey plume of smoke is framed. True the locomotive is missing and as for the train – you do not see it. The smoke is enough for me, because it represents the fire which is the soul of the machine, and the machine . . . is the intelligence, the glory, and the fortune of our century. For posterity, the symbol of our nineteenth century will be a locomotive.'

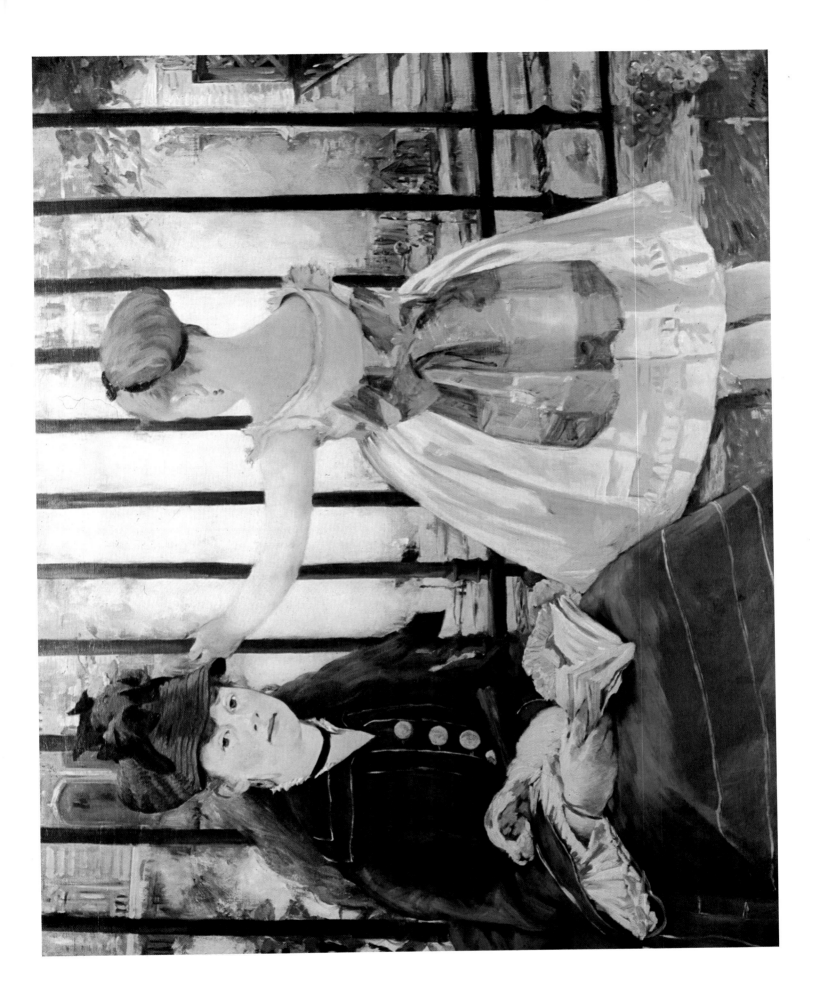

1874. Oil on canvas, 80 x 98 cm. Bayerische Staatsgemäldesammlungen,
(Neue Pinakothek), Munich

Claude Monet acquired his studio boat in about 1873, and used it to make
painting trips up and down the Seine in search of new motifs. In 1874
Manet painted him, accompanied by his wife Camille, painting on his boat
against a background of the Argenteuil bank of the Seine. The canvas on
which Monet is working is possibly *The Red Boats, Argenteuil* (Jeu de Paume,
Musée du Louvre, Paris).

Manet and Monet often worked together at Argenteuil (Manet had a
weekend house at Gennevilliers on the opposite bank), and his association
with Monet helped him to formulate a new attitude to painting *en plein air*,
and to lighten his palette (Fig. 26). In this work certain areas, especially at
the bottom left, are painted using short brushstrokes and touches of juxta-
posed complementary colour that resemble Monet's technique. Other
areas of the canvas, however, reveal no interest in conveying a sense of
light, and are painted as flat areas of colour, setting side by side large
patches of colour rather than small dabs, as in the red roofs and green trees
on the bank, and the yellow and blue of the studio boat. On the horizon are
visible the smoking chimneys of small factories, easily accepted by Manet
as part of the changing face of the landscape, and given the same emphasis
as the masts of the boats.

Although Manet was frequently in the company of members of the
Impressionist group – Berthe Morisot, Degas, and Monet in particular –
and was regarded by the Impressionists as a leader, he had no wish to join
their group, believing that 'the Salon is the real field of battle'. He was
naturally irritated by the critics' tendency to confuse him with Monet.

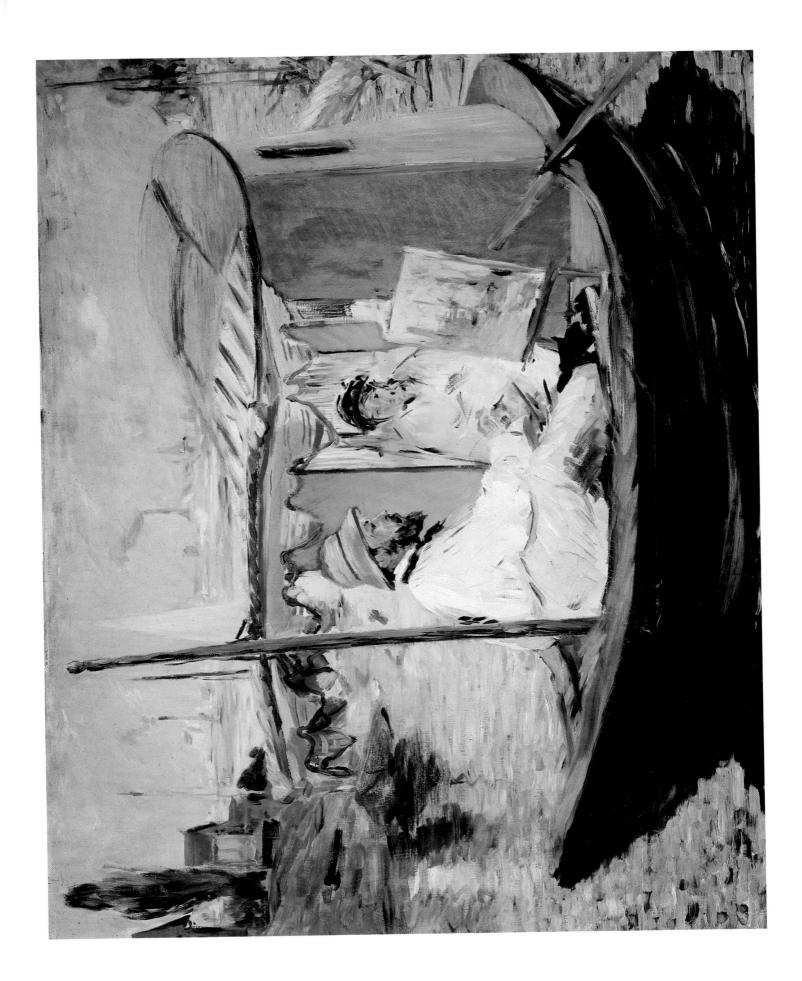

1874. Oil on canvas, 149 x 131 cm. Musée des Beaux-Arts de Tournai

This painting was shown at the 1875 Salon, Manet's only submission, and it attracted the seemingly inevitable flood of sarcasm and outraged indignation. The caricaturist Stop added this caption to his cartoon (*Le Journal Amusant*):

'"Good Lord! What's that?"
"That's Manet and Manette."
"What are they doing?"
"I think they're in a boat."
"But that blue wall?"
"That's the Seine."
"Are you sure?"
"Well, someone told me so."'

On the day the Salon closed, Cham showed the couple stepping out of their frame, with the comment: 'Manet's two canoers aren't sorry to leave, since people have been laughing in their faces for almost two months' (*Charivari*).

These facetious comments highlight one of the painting's most striking aspects. As in *The Railway* (Plate 28), the figures are set extremely close to the picture plane, and various devices are used to link foreground and background areas, thus stressing the two-dimensionality of the picture surface. For example, the mast running down the left-hand side of the canvas links different areas on the same spatial plane, while the diagonal of the bowsprit links the foreground and the background across the blue band of the water.

The young woman in her striped dress and black straw hat ignores the yachtsman who leans towards her, with the self-contained detachment that is characteristic of many of Manet's portraits of women (see Plate 39). The male model was probably Manet's brother-in-law Rudolf Leenhoff.

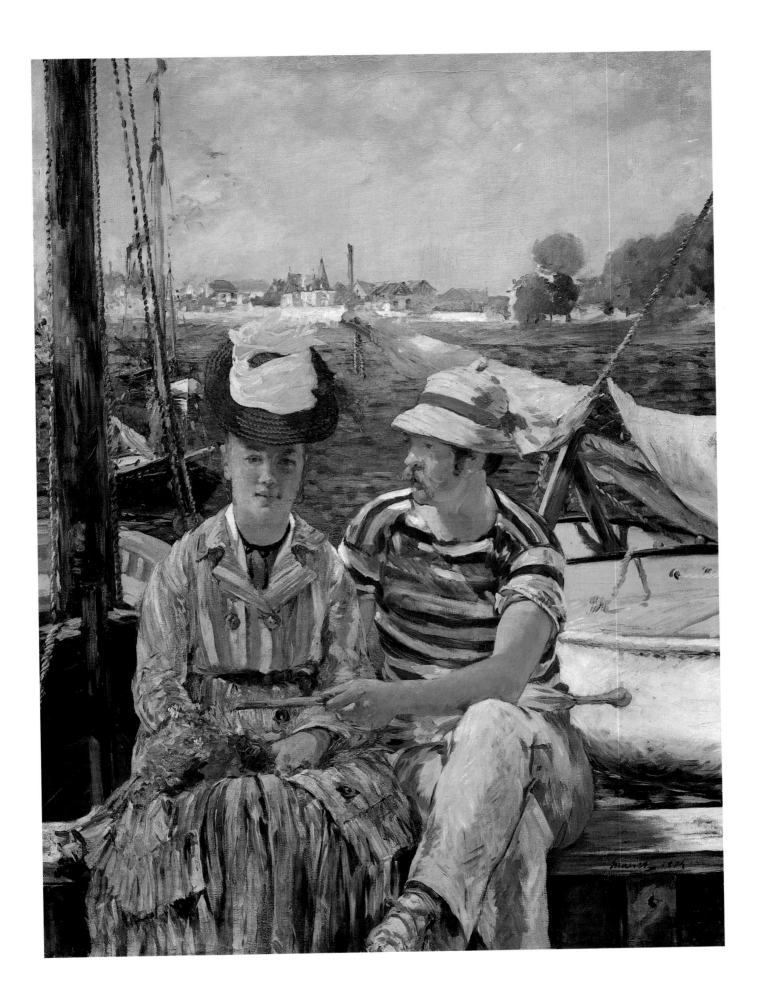

1874. Oil on canvas, 96 x 130 cm. Mrs H.O. Havemeyer collection, The Metropolitan Museum of Art, New York

Painted at Gennevilliers in the summer of 1874, this painting was not shown until the Salon of 1879, when Manet submitted it together with *The Conservatory* (Plate 39). The man is the same model who appeared in *Argenteuil* (Plate 30), probably Rudolph Leenhoff, although Jacques-Emile Blanche said he was Baron Barbier, a close friend of Guy de Maupassant. The woman may be Camille Monet, wearing the same hat as in *The Banks of the Seine at Argenteuil* (Fig. 26).

The painting is conceived as literally a slice of *la vie moderne*. The composition is boldly cut off so that only a small section of the sail is visible, and the spectator looks down into the boat. This angle of vision removes the horizon line and makes it impossible to gauge the space of the painting, thus creating a pictorial tension between implied depth and emphasized two-dimensionality.

Manet uses a broken brushstroke technique in the striped dress to produce an effect of shimmering light fabric, but unlike the Impressionists, he does not use this technique to convey the effect of sunlight modifying local colour. The man is precisely outlined against the brilliant blue of the water, and his white clothes have only a few grey brushstrokes to indicate shadow.

The painting combines a typically Impressionist subject, the Seine and *canotage*, with a technique that is often found in Japanese prints. Huysmans noted in his Salon review that the boat is 'cut off by the frame as in certain Japanese prints', and it is characteristic of Manet's approach to have combined his direct observation of the boating couple with a compositional device that recalls other pictures.

Fig. 26
The Banks of the
Seine at Argenteuil

1874. Oil on canvas,
62 x 103 cm.
Private collection, (on loan
to the National Gallery,
London)

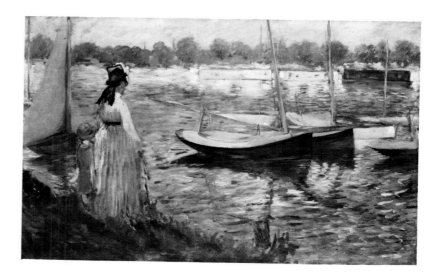

The Grand Canal, Venice

1874. Oil on canvas, 57 x 48 cm. Property of the Provident Securities Company, San Francisco

Manet travelled to Venice with James Tissot in September 1874. Tissot, who was four years Manet's junior, had settled in London after the Franco-Prussian War.

This painting shows the dome of Santa Maria delle Grazie seen at an angle that suggests that Manet may have based it on sketches made from a gondola. The posts in the canal, the *palli*, dominate the view, which is similar to that painted by Claude Monet in 1908 (*The Grand Canal, Venice*, Private collection). Manet and Tissot, and later Monet, stayed at the Palazzo Barbaro on the Grand Canal as the guests of Mr and Mrs Curtis. Curtis was a close friend of John Singer Sargent and of Henry James. Both this painting and the other version (Fig. 27) suggest Monet's recent influence on Manet's work in the dappled reflections in the water of the canal.

The extreme sketchiness of the building on the left indicates that, as Monet was to do thirty-four years later, Manet completed this view from memory. Monet said when his Venetian paintings were praised: 'They are horrid. They are worthless and I will explain to you why. I went to Venice with my wife. I took notes and should have gone back there. But my wife died and I never had the courage. So I finished them off from memory and nature has had its revenge. You see, I could do views of Paris from memory and no one but myself would notice. But in Venice, it's a different matter'.

Manet found Venice boring, and had great difficulty in painting the constantly changing reflections, which he described as being 'like the floating bottoms of champagne bottles'. 'It's the very devil,' he wrote, 'to succeed in giving the feeling that a boat has been constructed with wood cut and shaped in accordance with geometrical rules!'

Fig. 27
Blue Venice

1874. Oil on canvas,
58 x 71.5 cm.
Courtesy of Shelburne
Museum, Shelburne,
Vermont

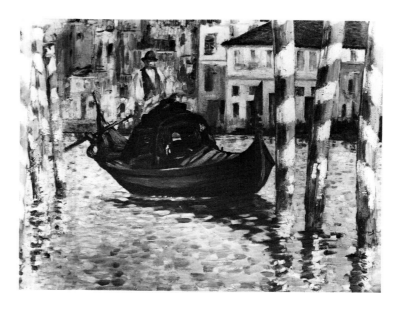

33 Portrait of Stéphane Mallarmé

1876. Oil on canvas, 27.5 x 36 cm. Musée d'Orsay, Paris

This portrait of his close friend the poet Mallarmé is in marked contrast to Manet's earlier portrait of Emile Zola (Plate 16). There, Manet concentrated on the attributes surrounding and defining Zola, while here, Mallarmé is shown in a relaxed pose in an armchair, reading and smoking a cigar, with only a simple wallpaper design behind him. All Manet's attention is concentrated on the figure itself. This small canvas was rapidly painted, perhaps in a single sitting, and is an affectionate portrait of an intimate.

Manet had met Mallarmé, ten years his junior, late in 1873, and they were in the habit of seeing each other almost daily. Mallarmé wrote about Manet's work in 1874 – 'Le Jury de Peinture pour 1874 et M. Manet' (*La Renaissance artistique et littéraire*) – and in 1876 – 'The Impressionists and Edouard Manet' (*Art Monthly Review*). Manet in his turn had illustrated Mallarmé's translation of Edgar Allan Poe's *The Raven* and made a number of woodcut illustrations for *L'Après-midi d'un Faune*, which was published in April 1876.

Mallarmé's understanding of Manet's aims and methods was sure and perceptive. He wrote: 'What is an "unfinished" work, if all its elements are in accord, and if it possesses a charm which could easily be broken by an additional touch?'

The question could well be asked of this picture, so fluent in its rendering of Mallarmé's appearance and personality, so economical in its means.

Nana

1877. Oil on canvas, 150 x 116 cm. Hamburger Kunsthalle

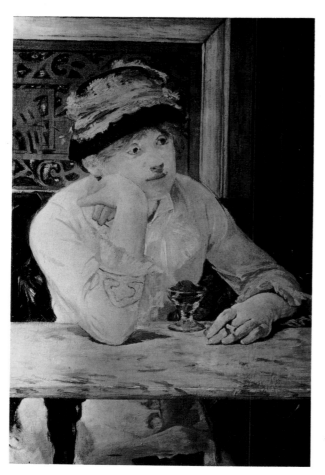

Fig. 28
The Plum

1877. Oil on canvas,
74 x 49 cm.
Mellon collection,
National Gallery of Art,
Washington DC

Nana was a character in Emile Zola's novel *L'Assommoir*, which was being serialized at the time Manet was planning and executing the painting. Manet told Zola that he was reading *L'Assommoir* and found it 'amazing'. Huysmans announced Zola's intention to write a full-length novel about Nana in a notice on Manet's painting in May 1877 and he congratulated Manet on having 'shown her as she will undoubtedly be [in it], with her complex, refined vice, her extravagance, and her wealth of lewdness'. Zola's novel, *Nana*, was serialized in *Le Voltaire* from October 1879 to February 1880 and published in book form in February 1880.

In one of the scenes in the novel, Nana's lover Count Muffat watches his mistress in agonized concentration as she poses naked in front of a mirror, oblivious of him. Henry Céard had suggested the scenario for this episode to Zola, describing the woman as wearing mauve stockings, boots, and nothing else. Manet's painting may have provided the original impetus for the description, although his Nana stands in front of her mirror in her underwear.

Manet asked Henriette Hauser, a well-known *grande cocotte*, to pose for him and arranged a corner of his studio as a dressing-room, even providing special heating. Henriette Hauser was kept by the Prince of Orange, and so was nicknamed '*Citron*'. Prominent in the background of the painting is a wall-hanging with a Japanese crane (*Grus japonensis*), which is also visible in *The Woman with the Fans* (Fig. 5). '*Grue*' or 'crane' was a common term for a courtesan. Nana's expression, looking over her shoulder as if to check that her admirer was completely captivated, contrasts with Olympia's direct, unwavering stare (Plate 7).

This painting, *The Plum* (Fig. 28) and *Skating* (Fig. 9) were all conceived of by Manet as 'naturalistic subjects', and further explorations of *la vie parisienne*.

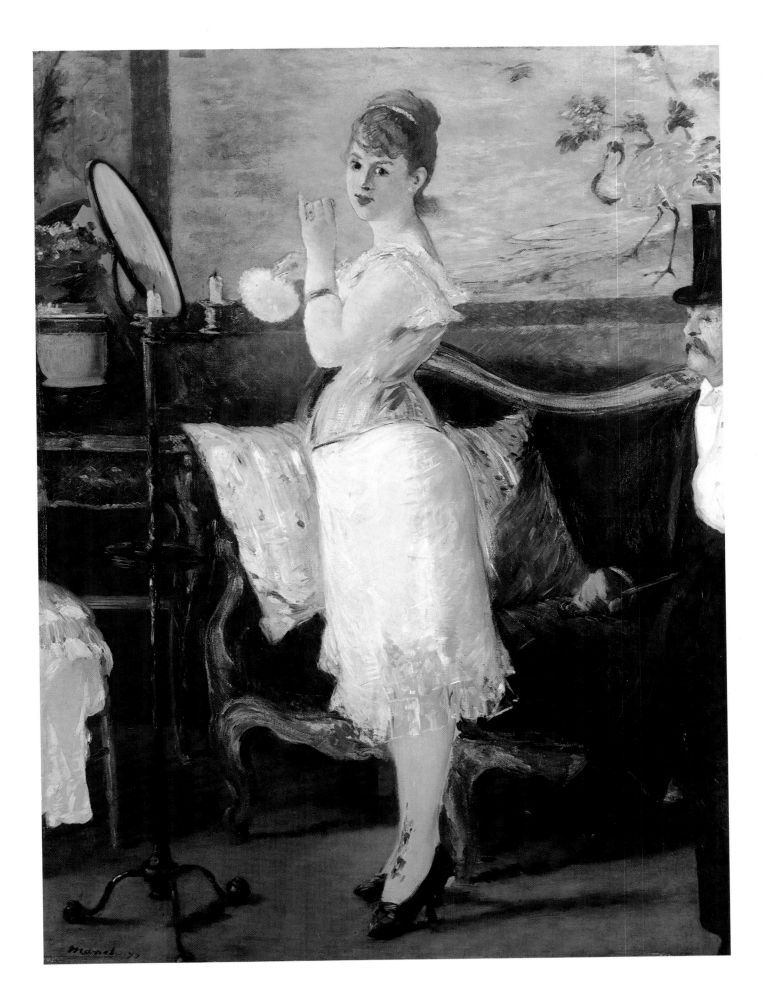

1878. Oil on canvas, 63 x 79 cm. Private collection

Manet painted the view from his studio at 4 rue de Saint-Pétersbourg looking along the rue de Berne (then the rue Mosnier) to its intersection at an oblique angle with the rue de Moscou, on several occasions during 1878. Apart from this version, the other views of the road show it decorated with flags for the first *Fête Nationale* held in France since 1869. One of these views (Paul Mellon Collection, Upperville, Virginia), shows the street almost deserted except for a one-legged man on crutches, a *mutilé de guerre*, who serves as a reminder of the Franco-Prussian War and the Commune.

Manet made two preliminary drawings for this painting (Fig. 29), and separate oil sketches of the cab and the figure in front of the lamppost. This careful preparation is then combined in the final painting with an impressionistic technique which suggests spontaneity and is concerned with conveying an overall effect rather than precise detail. The bending figures of the road-menders in the foreground, for example, are indicated with a few strokes of the brush, and so too is the greenery on the balconies of the houses.

The billboard advertising beer on the end of the left-hand row of buildings was intended to be seen by train passengers leaving the Gare St Lazare. The open area behind the fence at the left of the painting is not a building-site, part of the Haussmannization of Paris, but railway land, the cutting visible behind the figures in *The Railway* (Plate 28), and a reminder of the proximity of Manet's studio to the station and the railway tracks.

Fig. 29
Rue de Berne

1878. Pencil and wash on paper, 19 x 35 cm. Museum of Fine Art, Budapest

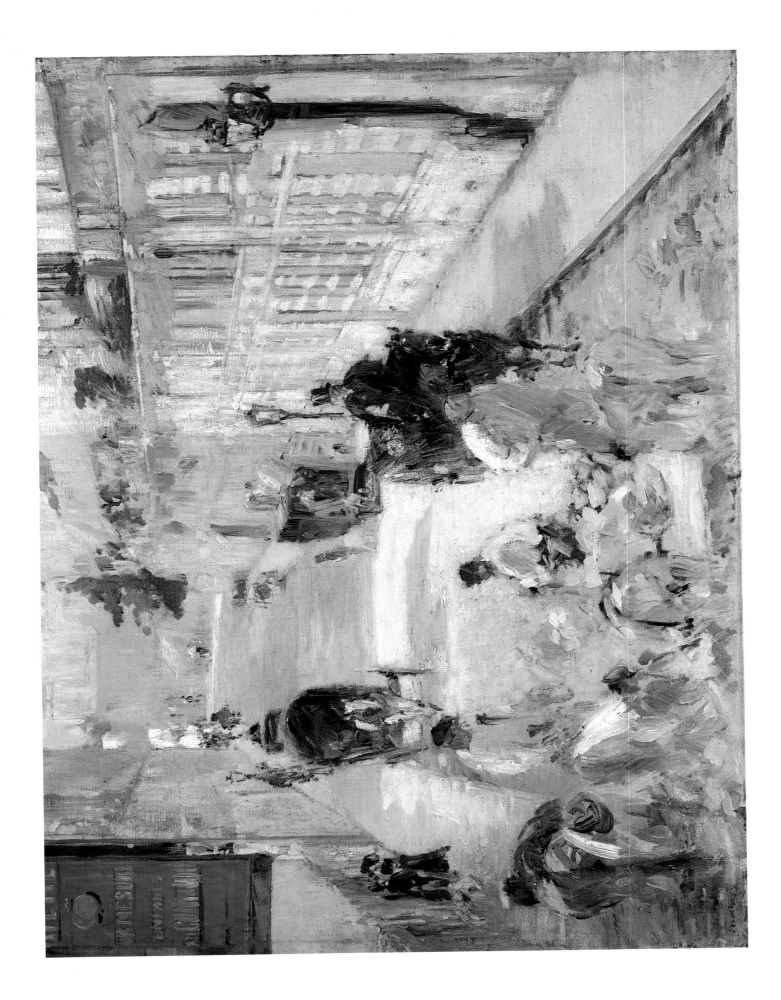

Blonde with Bare Breasts

c.1878. Oil on canvas, 62.5 x 51 cm. Musée d'Orsay, Paris

In 1878 Manet began to suffer from headaches and a numbness which occasionally paralysed his left leg. Although he painted continuously, he found that he quickly became exhausted and he began to explore the possibilities of pastel and mixed media (Plate 41), which required less physical effort than oil painting. This painting is an oil, but the pigment is diluted with turpentine and applied as a thin wash. The canvas ground shows through in many areas and scarcely any part of the canvas is more than one layer of paint thick, suggesting that the work may be the result of a single sitting. The boldly painted outline which defines the body is as precisely drawn as if by a Japanese calligrapher. 'Only Manet and the Japanese', Berthe Morisot had said, 'are capable of indicating a mouth, eyes, a nose, in a single stroke, but so concisely that the rest of the face takes on modelling.'

The model wears a straw hat decorated with poppies, the scarlet of the poppies contrasting with the green background against which she is set in profile. Manet has captured her decorativeness and charm, but her face, with its *retroussé* nose and languid, rather vacant expression has none of the striking qualities that are remarkable in the majority of Manet's portraits of women. Her slightly downcast, sideways gaze, which does not meet the spectator's eye, is more in accord with convention than the challenging or wryly amused expression of many of the female portraits in his *oeuvre*.

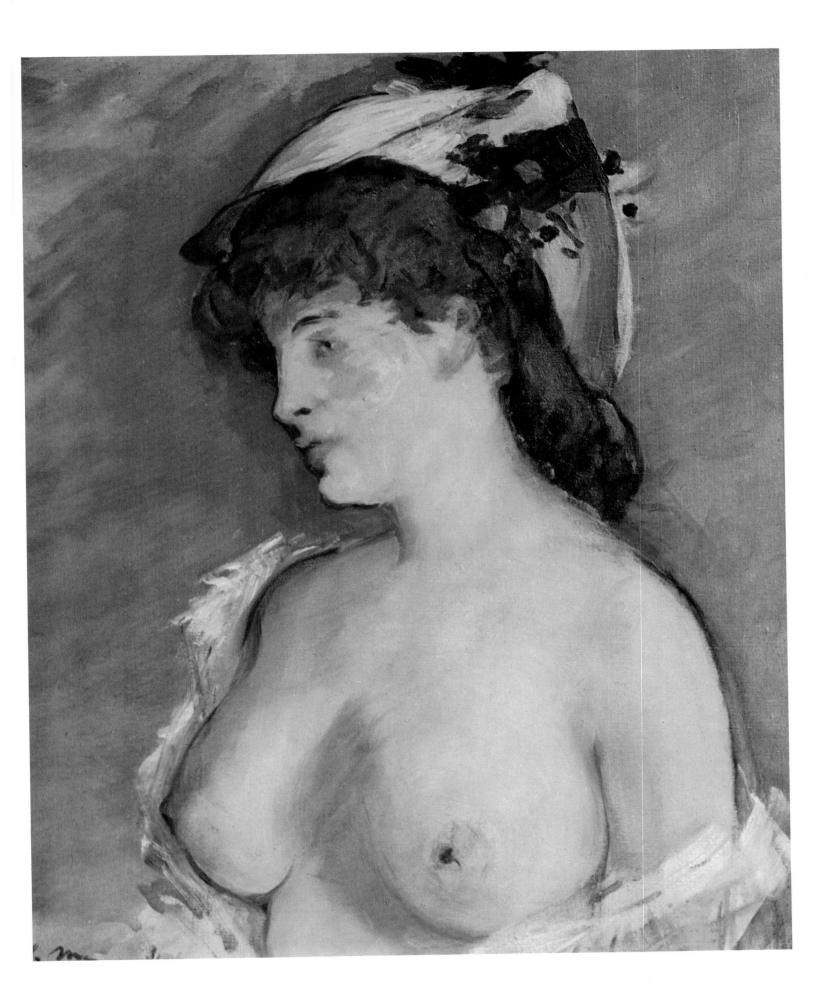

c.1878-9. Oil on canvas, 73 x 92 cm. Rouart collection, Paris

This painting of a café-concert under the trees on the Champs-Elysées is a rapidly painted record of a phenomenon that had probably originated in the 1840s and enjoyed its heyday from the mid-1860s to the mid-1880s. Figures on the number of cafés-concerts in the 1870s vary, but there appear to have been at least 120 in central Paris. On the Champs-Elysées the performances took place in small pavilions, considerably raised off the ground, with open sides hung with drapes. The patrons sat at tables clustered about the stage, or stood at their periphery, and the waiters served drinks from bars set up on tables at the edge of the crowd. Daumier commented, in a lithograph showing a Champs-Elysées café-concert: '*On n'a jamais su si c'est la musique qui fait passer la bierre, ou si c'est la bierre qui fait avaler la musique*'.

Manet depicts the *chanteuse* from very close quarters, so that she looms above us. In the centre foreground is a portion of a top hat, and to the left of this is the conductor. The crowd is a blur, with no clearly defined forms visible, an indication that Manet was painting the view from the stage, conveying the impression the entertainers had of their audience.

The audience was one in which class divisions were as blurred as their appearance is in this painting. Apprentices wore their *habit noir*, the bourgeoisie appeared *en veste* and wearing caps. As T.J. Clark has observed: 'The café-concert was a place of exchange: exchanging selves, shifting identities' (*The Wolf and the Lamb: Popular Culture in France*, 1977).

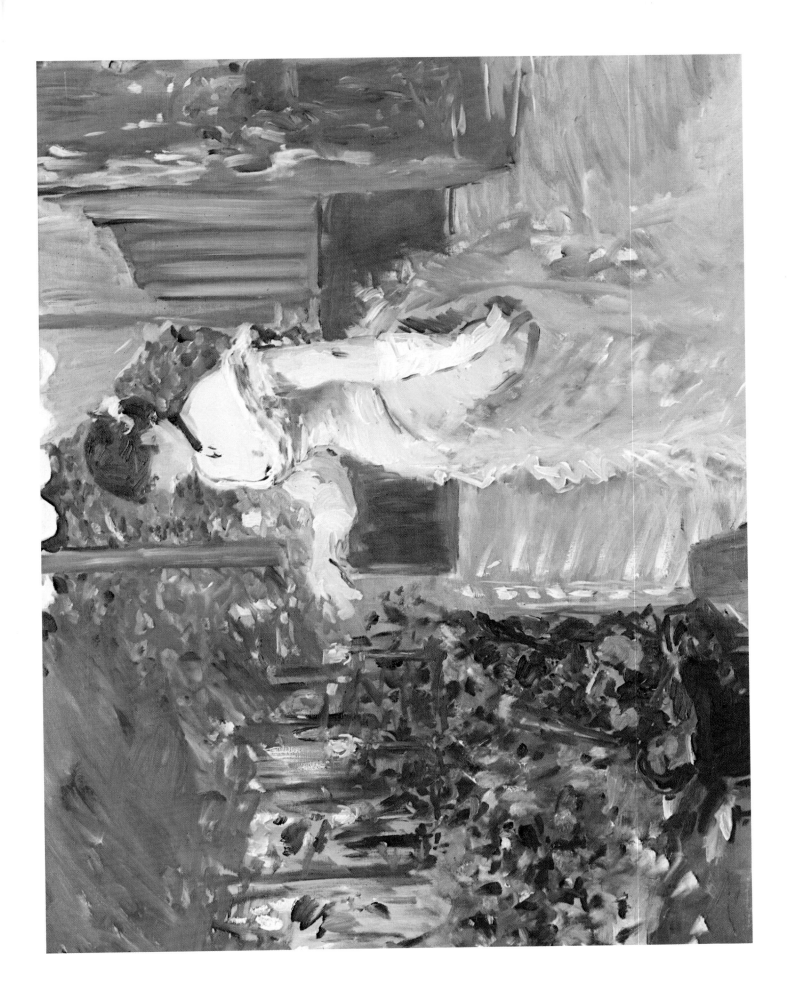

38　The Waitress

c.1879. Oil on canvas, 77.5 x 65 cm. Musée d'Orsay, Paris

A larger version of this subject is in the National Gallery, London. Martin Davies in the catalogue of the National Gallery states that he believes that version to be the right-hand portion of a large canvas called *Café-concert de Reichshoffen*, begun in August 1878, which Manet is known to have cut in two before completion. Richardson believes that it is more likely that the Louvre version (reproduced here) is the other half of the large canvas, the left-hand section being *At the Café* (Winterthur, Stiftung Dr Oskar Reinhart).

The Brasserie de Reichshoffen was on the Boulevard Rochechouart. Waitresses were a comparatively recent innovation in Parisian brasseries, and one of them agreed to pose for Manet. She insisted that she be accompanied by her *galant*, the man in the blouse in the foreground of the painting. They came to the studio Manet had rented for the period between leaving his rue de Saint-Pétersbourg studio and occupying a new studio on the rue Amsterdam.

The painting reveals the social mix to be found in the night-spots of Paris (see also Plate 37). The man in the foreground, in his workman's blouse, smoking a clay pipe, is next to a man in *habit noir* and an elegantly coiffed woman. The figures are placed in a tightly compressed space, with the vertical stripe of the wall-hanging acting as a barrier to the reading of depth. The figure performing on the stage is cut off so abruptly that only an arm, a skirt and the hint of a head are visible, perhaps largely as a result of the mutilation of the canvas, but also as a suggestion that the stage acts were not the major *raison d'être* of the cafés-concerts and brasseries.

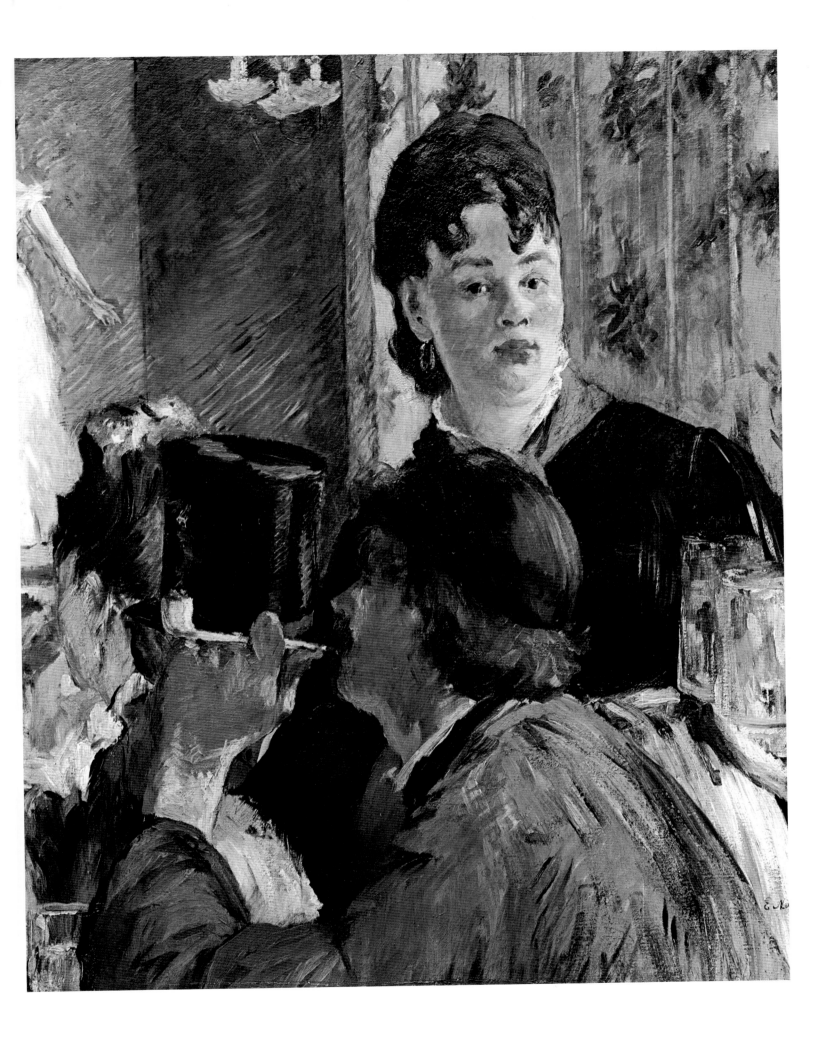

The Conservatory

1878-9. Oil on canvas, 115 x 150 cm. Gemäldegalerie, Staatliche Museen Preussischer Kulturbesitz, Berlin

From July 1878 to April 1879 Manet rented a studio from the Swedish painter Count Johann Georges Otto Rosen while his new studio at 77 rue d'Amsterdam was being prepared, and he painted this work and *Madame Edouard Manet in the Conservatory* (Fig. 30) in the conservatory adjacent to this studio.

The couple in the painting are Monsieur and Madame Jules Guillemet, who owned a fashionable dress-shop on the rue Saint-Honoré. Madame Guillemet was American, and one of the few *femmes du monde* of Manet's acquaintance who was also a friend of Suzanne Manet's. Manet encouraged his wife to visit the studio while he was engaged on this painting, contrary to his usual practice, and urged her to talk to the Guillemets and keep them amused. 'Talk, laugh, move about,' he said, 'you will only look real if you keep lively.'

Manet worked on the painting from September 1878 to February 1879, and, for all Madame Manet's efforts, it is stiff and posed-looking. Madame Guillemet's grey dress with its fan of pleats and mustard-yellow accessories is displayed to good advantage as she sits on the conservatory bench. Her independence from her husband, whom she ignores completely, and her sense of self have been seen as qualities representative of the modern *haute bourgeoise* (Lipton, *Artforum*, March 1975). Renoir's exactly contemporary painting of *Madame Charpentier and her Children* (New York, Metropolitan Museum of Art) imbues Madame Charpentier with a similar self-possession and detachment.

The background plants create a dense screen behind the couple, compressing the space of the painting and, as in *Argenteuil* (Plate 30), pushing the figures to the extreme foreground. The exotic beauty of the plants serves to heighten Madame Guillemet's air of studied elegance.

Fig. 30
Madame Edouard Manet in the Conservatory

1879. Oil on canvas, 81.5 x 100 cm. National Gallery, Oslo

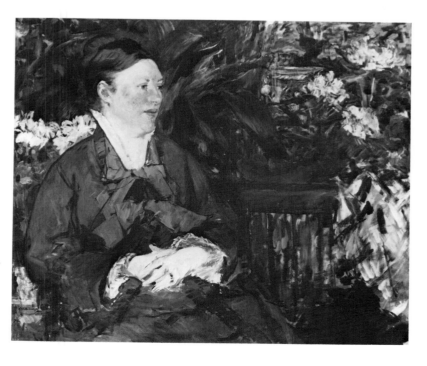

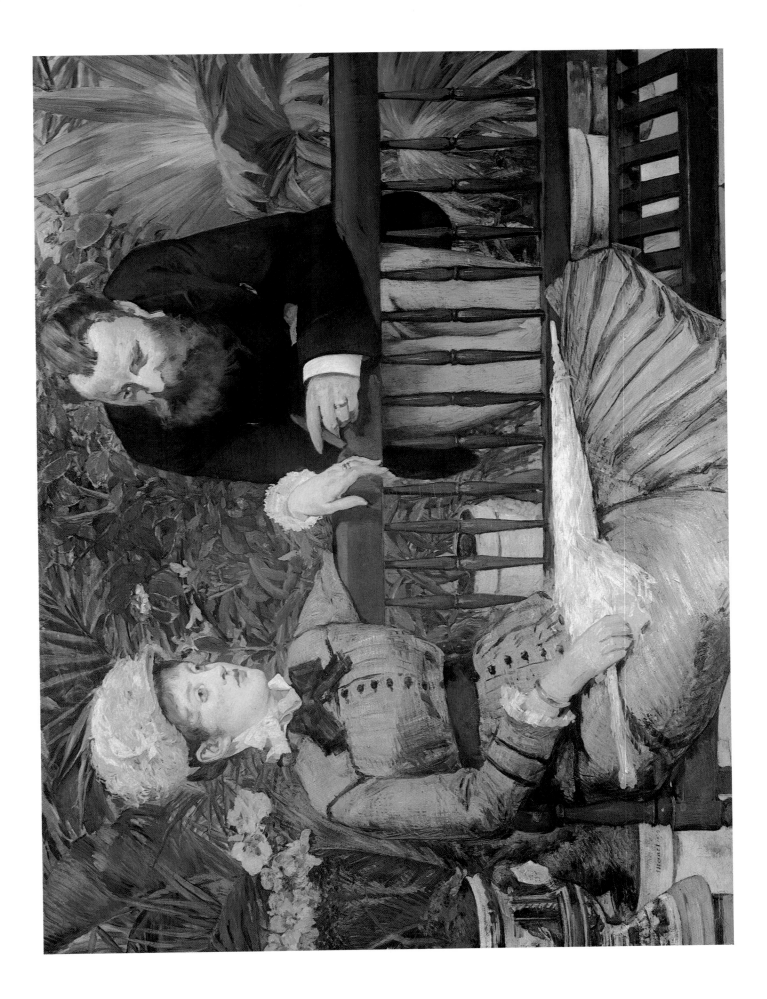

At Père Lathuille's

1879. Oil on canvas, 93 x 112 cm. Musée des Beaux-Arts de Tournai

The restaurant *Chez le Père Lathuille* was almost next door to the Café Guerbois, Manet's 'headquarters'. The son of the proprietor, Louis Gauthier-Lathuille, described the origins of the picture:

'. . . in July 1879 when on leave from military service, I met Manet outside our house. He admired my appearance and said to my father, "I have an idea. I am going to paint your son as a dragoon." He got Ellen Andrée [the actress] to come – young, sweet, amusing, dressed to kill . . . It was charming. The picture came along fine. There were two sittings . . . But at the third sitting, no Ellen Andrée . . . The day after, she reappeared, but a bit late . . . She had been rehearsing. Furious, Manet decided to get rid of her . . . The next day I saw him arrive with Judith French, a relation of Offenbach's. I took up the same pose with her, but it was not the same thing. Manet appeared nervous. "Take off your uniform," he finally said, "and put on my smock" . . . That's how it came about that I posed as a civilian with Mlle French.'

The painting, with the young man gazing soulfully at the woman, holding his champagne glass, while the waiter carrying a coffee pot stands on the right, looking at the couple, is a humorous and delightful vignette of contemporary life. Manet uses 'body language' as an important element in the picture, as Renoir frequently did (Fig. 31).

At Père Lathuille's was exhibited at the Salon of 1880, subtitled 'In the Open Air'. Théophile Silvestre wrote:

'All is brightness and joy in this corner of a restaurant . . . There is truly extraordinary vitality in this little scene of everyday life, and Manet has never asserted with more intensity his limpid vision, so delicate and true, the clarity of his impressions, and the personal resources of his palette.'

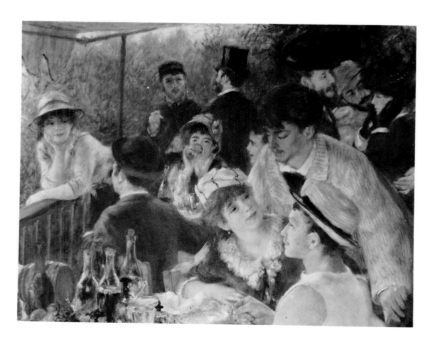

Fig. 31
Pierre Auguste
Renoir:
Detail of 'The
Luncheon of the
Boating Party'

1881. Oil on canvas,
129.5 x 172.5 cm.
The Phillips collection,
Washington DC

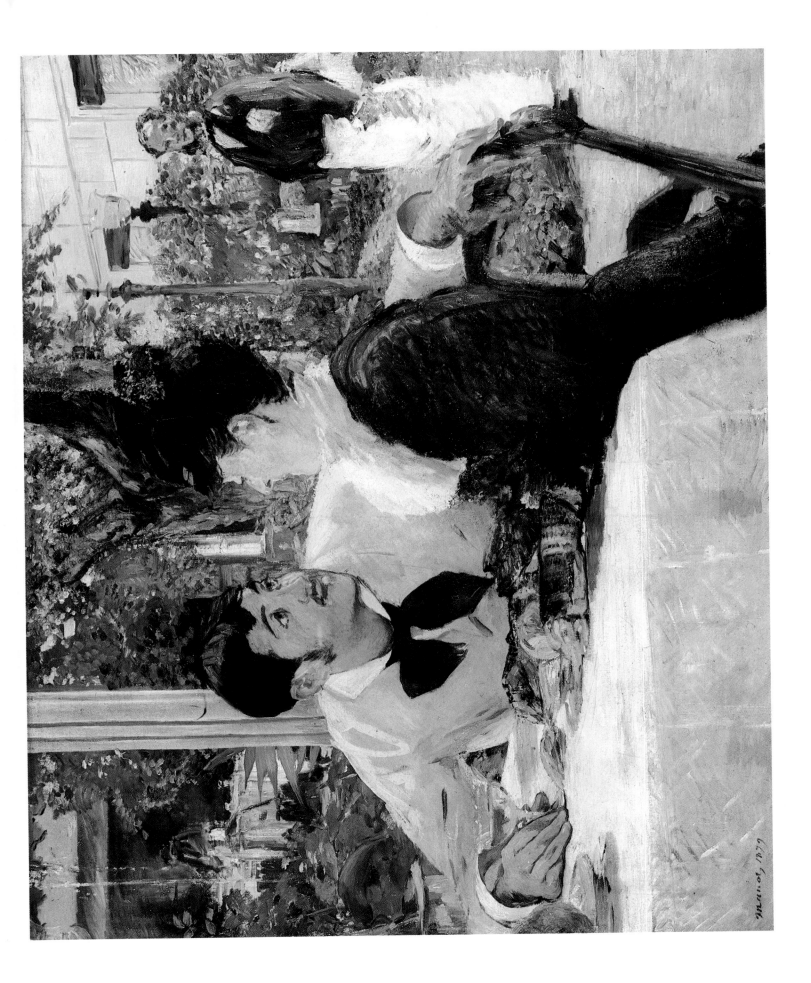

c.1880. Oil and pastel on linen, 32 x 45 cm. The Burrell collection, Glasgow Museums
and Art Galleries

Fig. 32
Woman with a
Black Hat

1882. Pastel, 55.5 x 46 cm.
Musée d'Orsay, Paris

In 1880 Manet spent about six months attending a hydropathic clinic at Bellevue, just outside Paris, in an attempt to alleviate the pain in his legs. Emilie Ambre, the opera singer, who had taken *The Execution of Maximilian* (Plate 14) to the United States the previous year, leased him her villa. He endured the treatments of baths and massage three times a day, calling the cure an 'atrocious torture'. In the many letters he wrote to friends at this time he complained of his boredom and yearned to be back in Paris. 'Really the country has charm only for people who don't have to remain in it', he told Zacharie Astruc, and to Méry Laurent he wrote, 'If it is a question of penance, my dear Méry, I am undergoing it, and as never before in my life!'

At the beginning of November 1880 he returned to Paris, and was revitalized by his renewed contact with his friends and with the café life of Paris. This small picture probably dates from the winter of 1880-1, and shows the interior of a café on the Place du Théâtre Français. The young girl, her features blurred, sits at the table with a faceless man puffing a cigar. The large mirror in the background increases the sense of the dreary emptiness of the café, and its use anticipates *A Bar at the Folies-Bergère* (Plate 46). Both in mood and in its technical experimentation, combining the use of oil and pastel, this picture is close to the work of Degas, for example *L'Absinthe* (Musée du Louvre, Paris). At the 1880 Impressionist exhibition the critic Albert Wolff, whose portrait Manet painted, asked: 'Why does a man like M. Degas remain in this agglomeration? Why doesn't he follow the example of Manet who long ago deserted the impressionists?'

Manet made increasing use of pastel, especially for portraits (Fig. 32), in the last years of his life, finding the medium less physically taxing than oils.

The Ham

c.1880. Oil on canvas, 32 x 42 cm. The Burrell Collection, Glasgow Museums and Art Galleries

During his enforced stay at Emilie Ambre's villa at Bellevue during 1880 Manet painted several still lifes, often of a single fruit, such as a pear or a lemon. One such still life was of a bunch of asparagus (Cologne, Kunstgewerbesmuseum). It was bought by Charles Ephrussi, the editor of the Gazette des Beaux-Arts, who sent Manet 1,000 francs instead of the 800 francs he had requested. Touched by Ephrussi's generosity, Manet painted a single stick of asparagus (Paris, Musée du Louvre, Jeu de Paume) and sent it to Ephrussi, saying: 'There was one missing from your bunch.'

This painting of a ham – although partly the result of the restrictions on his strength and his time imposed by his illness and his attempt at a cure – reveals Manet's ability to direct all his attention to small objects, the details of daily life, in a manner similar to that displayed by Japanese artists. Vincent van Gogh wrote in 1888:

'If we study Japanese art, we see a man who is undoubtedly wise, philosophic, and intelligent, who spends his time how? In studying the distance between the earth and the moon? No. In studying the philosophy of Bismarck? No. He studies a single blade of grass.'

The Ham and the related still lifes of 1880 are Manet's equivalent of the study of a 'single blade of grass'. *The Ham* is displayed on a gleaming pate with a knife carefully placed next to it, a Chardin-like simplicity of arrangement.

The painting was first purchased by the big game hunter Henri Pertuiset, whose portrait Manet painted in 1880-1 (São Paulo, Museum of Art), and then sold to Degas.

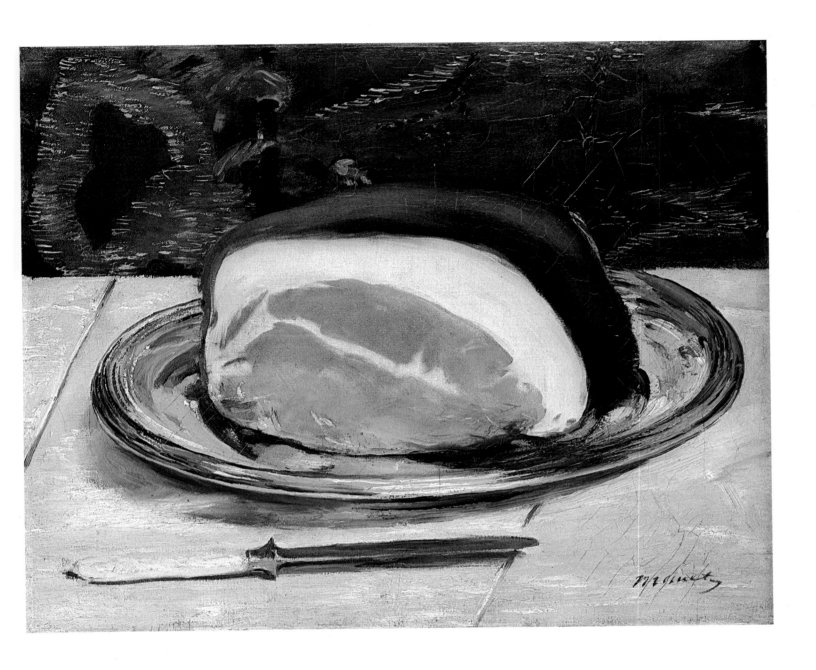

1881. Oil on canvas, 81.5 x 66.5 cm. Hamburger Kunsthalle

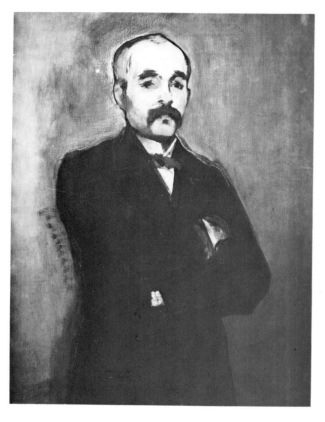

Fig. 33
Portrait of
Clemenceau

1879. Oil on canvas,
94.5 x 74 cm.
Musée d'Orsay, Paris

In July 1880 an amnesty was granted to the Communards and Manet conceived the idea of painting a portrait of Henri Rochefort. Rochefort, born Marquis de Rochefort-Lucay in 1830, had been condemned under military law to life-imprisonment for his part in the Commune. He had been transported to a penal settlement in New Caledonia in 1873. Four months later he and some other convicts escaped in a whale boat. He lived in Geneva and London until the amnesty made his return to Paris possible, and shortly thereafter he founded a new paper, *L'Intransigeant*.

Manet originally intended to depict the escape itself, and painted several versions showing the small boat on the open sea. One of these (Kunsthaus, Zurich) is a large painting, 146 x 116 cm., intended for Salon submission, but Manet was disappointed with it and determined to limit himself to painting Rochefort's portrait. Rochefort was not an admirer of Manet's work, but his cousin, Marcellin Desboutin, persuaded him to sit for Manet, and the portrait was accepted for the 1881 Salon. The jury could reasonably have rejected the painting on political grounds, for presenting a likeness of Rochefort to the Salon expressed Manet's unorthodox political sentiments as clearly as had his attempt to exhibit *The Execution of Maximilian* (Plate 14). One of the jury members, Alphonse de Neuville, wrote to Manet: 'I will not hide from you the fact that I would not have painted the portrait of Rochefort. At first it antagonized me toward you, but that has nothing to do with your qualities as a painter'.

Rochefort refused to accept Manet's painting, and it was sold to the singer Faure.

Ironically, the radical Rochefort later became a follower of General Boulanger and leader of the anti-Dreyfusards. Georges Clemenceau, whose portrait Manet painted in 1879 (Fig. 33), was to defend Emile Zola in the trial resulting from Zola's attack on the irregularities of the case against Dreyfus.

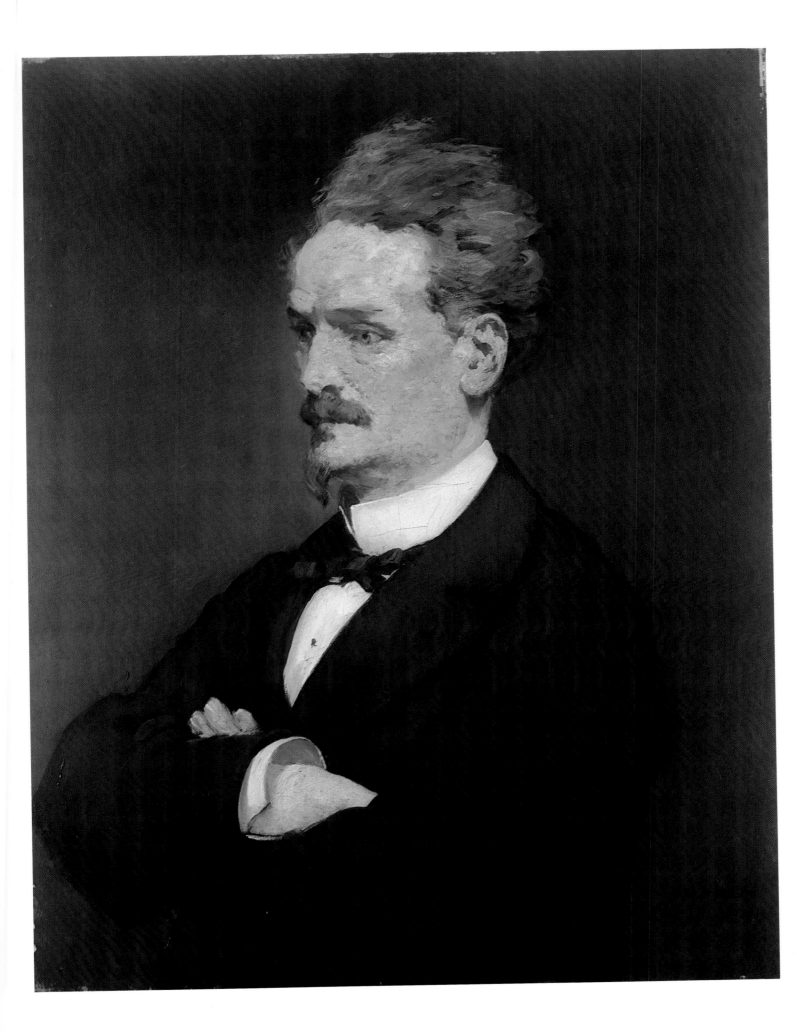

Clematis in a Crystal Vase

c.1881. Oil on canvas, 56 x 35.5 cm. Musée d'Orsay, Paris

During the last years of his life Manet painted many simple bunches of flowers, placed without pretence at formal arrangement in crystal vases. He found it relaxing to turn from a large canvas, which taxed his rapidly diminishing strength, to these small studies. He had always enjoyed being surrounded by flowers and painting them (Plate 10). Now, he said: 'I should like to paint them all'.

Like the still lifes of 1880, these flower paintings recall Japanese art in their recognition of the beauty of all plants or flowers. Here, the clematis, the Jackmanii variety, one of the commonest and most profusely flowering of all clematis, is set in a vase with a few of its leaves and some pinks to brighten the effect of the blue-purple blossom and the related blue of the background.

Many of the blossoms Manet painted are very short-lived as cut flowers, and paintings such as this may be seen as *vanitas* pictures. *A Herbal for the Bible*, published in 1587 (quoted by Slive, *Daedalus*, summer 1962), said that a man's life can be compared 'to a dreame, to smoke, to a vapour, to a puffe of wind, to a shadow, to a bubble of water, to hay, to grasse, to an herbe, to a flower, to a leave, to a tale, to vanitie, to a weaver's shuttle, to a winde, to dried stubble, to a post, to nothing'. Manet's flowers' brief lives may be seen as an indication of his awareness that his own life would soon be over.

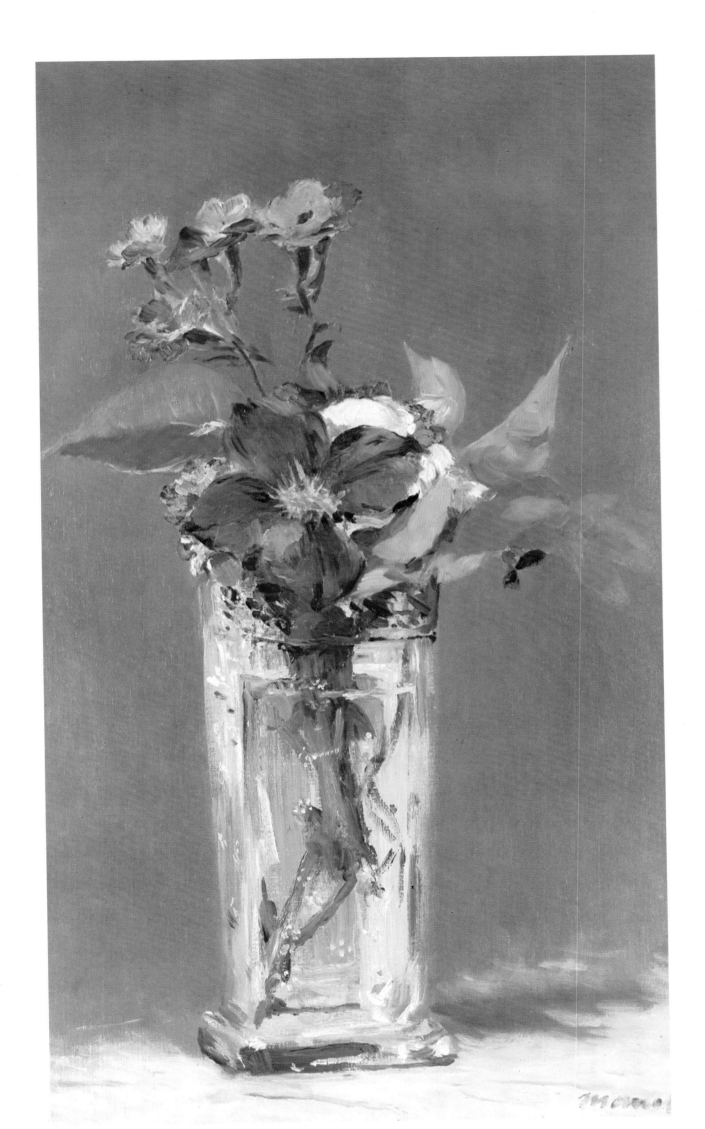

Autumn (Méry Laurent)

1881. Oil on canvas, 73 x 51 cm. Musée des Beaux-Arts, Nancy

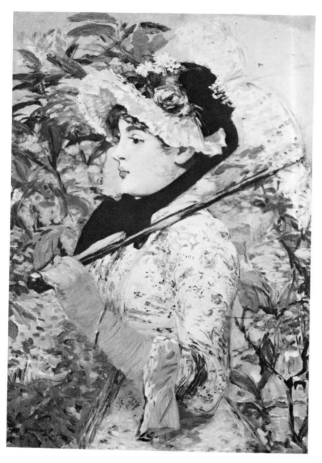

Fig. 34
Spring: Jeanne

1881. Oil on canvas,
73 x 51 cm.
Private collection

In autumn 1879 Manet conceived a decorative plan for the Hôtel de Ville in Paris. Proust recalled him saying: 'Allegory first of all, the wines of France, for example. The wine of Burgundy represented by a brunette, the wine of Bordeaux by a woman with chestnut hair, the wine of Champagne by a blonde.' This project was never realized, but in 1881 Manet completed this painting and *Spring: Jeanne* (Fig. 34), part of an allegory showing the beauties of the age as the Four Seasons. *Spring* was a considerable success at the 1882 Salon. Alfred Stevens, the Belgian painter and a friend of Manet's, had established a precedent for a modern-life recreation of the Four Seasons in 1876, as a commission from the King of the Belgians.

Méry Laurent was born in Nancy, where this painting now hangs, in 1849. At fifteen she married a grocer, but left him after a few months to join a cabaret revue. She attracted the attention of Dr Thomas W. Evans, an American who had been the dentist to Napoleon III and the Imperial Court. He kept her in considerable luxury, but artists and writers, it was said, enjoyed her favours for nothing. Méry is shown wrapped in furs which complement her chestnut hair and delicate complexion, against a wallpaper design of chrysanthemums.

The model for *Spring* was a young actress called Jeanne de Marsy, who is seen against a background of rhododendrons, wearing a dress and hat which Manet himself had chosen for her, both extremely fashionable and appropriately spring-like.

Manet did not include traditional attributes in this new kind of allegory. As he told a young artist, Georges Jeanniot, at this time: 'Concision, in art, is a necessity and a point of style; a concise man makes one reflect . . .'.

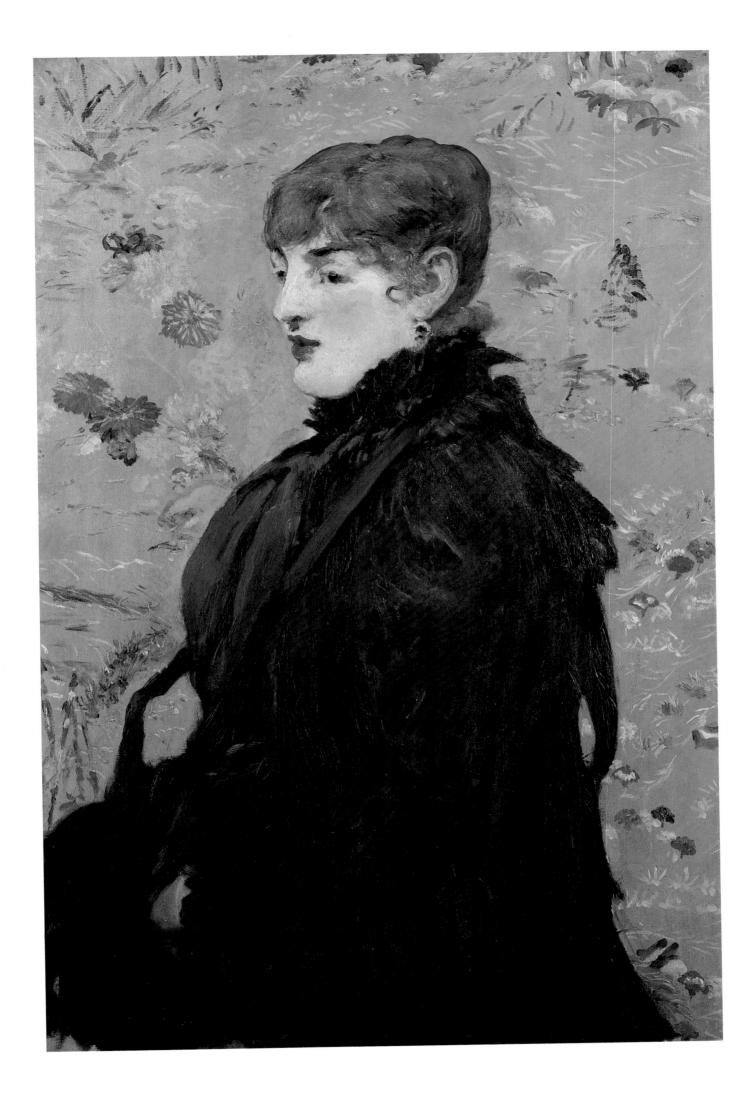

A Bar at the Folies-Bergère

1882. Oil on canvas, 96 x 130 cm. Courtauld Institute Galleries, London

Manet's last large-scale painting of Parisian life was one of two paintings (the other was *Spring: Jeanne* (Fig. 34)), that constituted his last Salon submission. As in the modern life evocations of the 1860s, the viewer is confronted with a dead-pan face, a directness of gaze that challenges and probes.

In this painting, the unresolvable problem of the pictorial space forces the viewer constantly to try to formulate a satisfactory answer to what is being shown. If there is a mirror behind the barmaid, what is it reflecting? The back view of the woman on the right must then be the central figure's mirror image, and yet it cannot be, for that would imply that the mirror is set at an angle to the picture surface, a reading contradicted by the frontality of the entire painting. The image of the man, for whom Henry Dupray was the model, is seen in the mirror and yet we cannot interpret where he must be standing to be seen in this position in reflection, unless he is outside the space of the painting, in 'real' physical space, the viewer himself;' . . . we begin to struggle for a reading, to include in the transaction all that the reflection contains and disallows. And we *cannot do it*, the equation will not be resolved' (T.J. Clark).

The bar shown is one of the many small bars that lined the wall of the public foyer of the Folies-Bergère. The display of bottles, fruit, and a vase of flowers is richly painted and as carefully observed as Manet's many contemporary still-life paintings (Fig. 35).

As in *Music in the Tuileries Gardens* (Plate 5), Manet here includes his friends. The painter Gaston Latouche, Méry Laurent (in white), and Jeanne de Marsy are identifiable among the blurred images reflected in the mirror.

Fig. 35
Detail of 'A Bar at the Folies-Bergère'

1882. Oil on canvas, 96 x 130 cm. Courtauld Institute Galleries, London

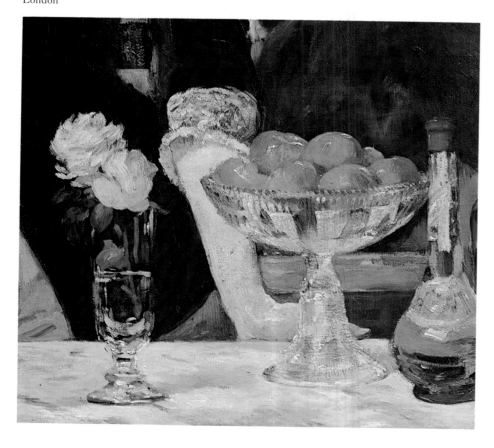

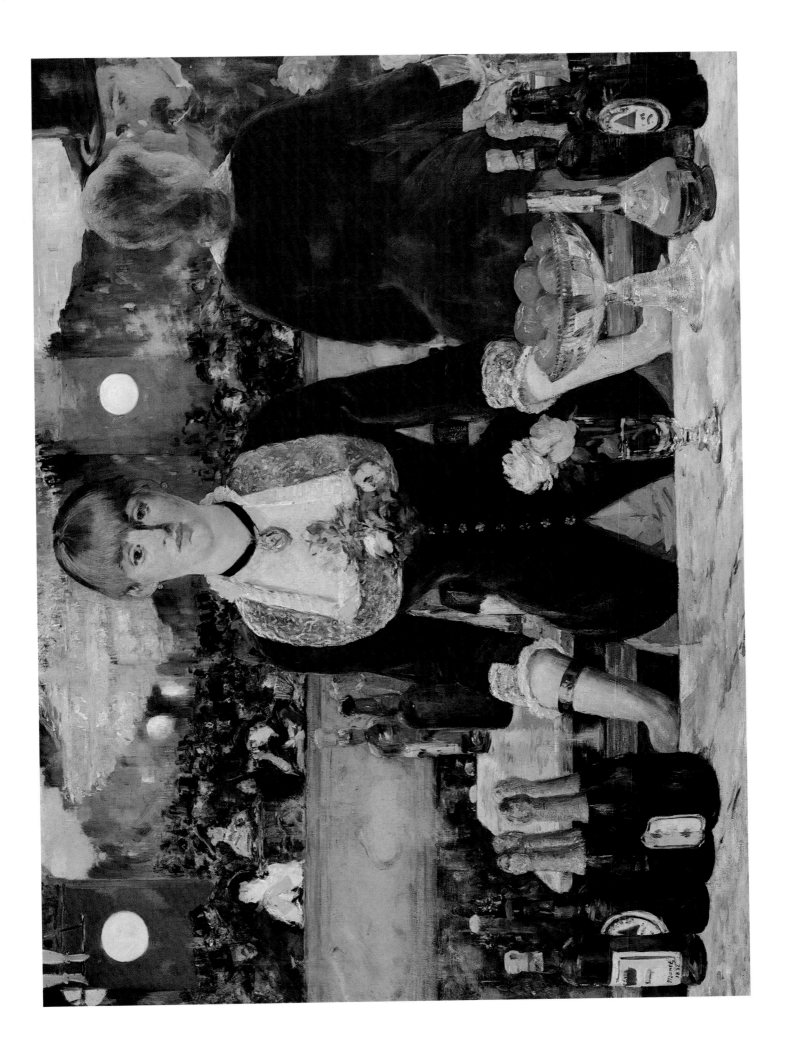

47 Villa at Rueil

1882. Oil on canvas, 92 x 73 cm. National Gallery of Victoria, Melbourne

In the summer of 1882 Manet decided that his health might benefit from a stay in the country, and he rented the house at Rueil, near Malmaison, which belonged to the dramatist Labiche. Eugène and Berthe were living nearby, at Bougival, and visited him frequently.

Manet did not find the house convenient, and the garden was unattractive. He was barely able to walk, and spent most of his days in a chair in the garden, where he painted two views of the house and garden (this and a horizontal version, now in the Staatliche Museen, Berlin). 'I need to work to feel well', he wrote to Méry Laurent.

The painting has a freshness that belies the difficulty with which Manet was working, for he was able to paint only for short periods interrupted by long rests. The broken brushstroke technique and elimination of unnecessary detail is impressionistic, and in this year the Impressionists had once again attempted to persuade Manet to join their ranks. Eugène Manet wrote to Berthe: 'Pissarro asked Edouard to take part in the exhibition [the 1882 Impressionist show]. I think he bitterly regrets his refusal. I have the impression that he hesitated a great deal.'

Success at the Salon, however, elusive for so long, was at last coming to Manet, and even Albert Wolff had grudgingly praised his work at the 1882 Salon. Manet wrote to Wolff: 'I thank you for the kind things you have said about me, but I should not be sorry to read at last, and while I am still alive, the splendid article you will write about me after I am dead.'

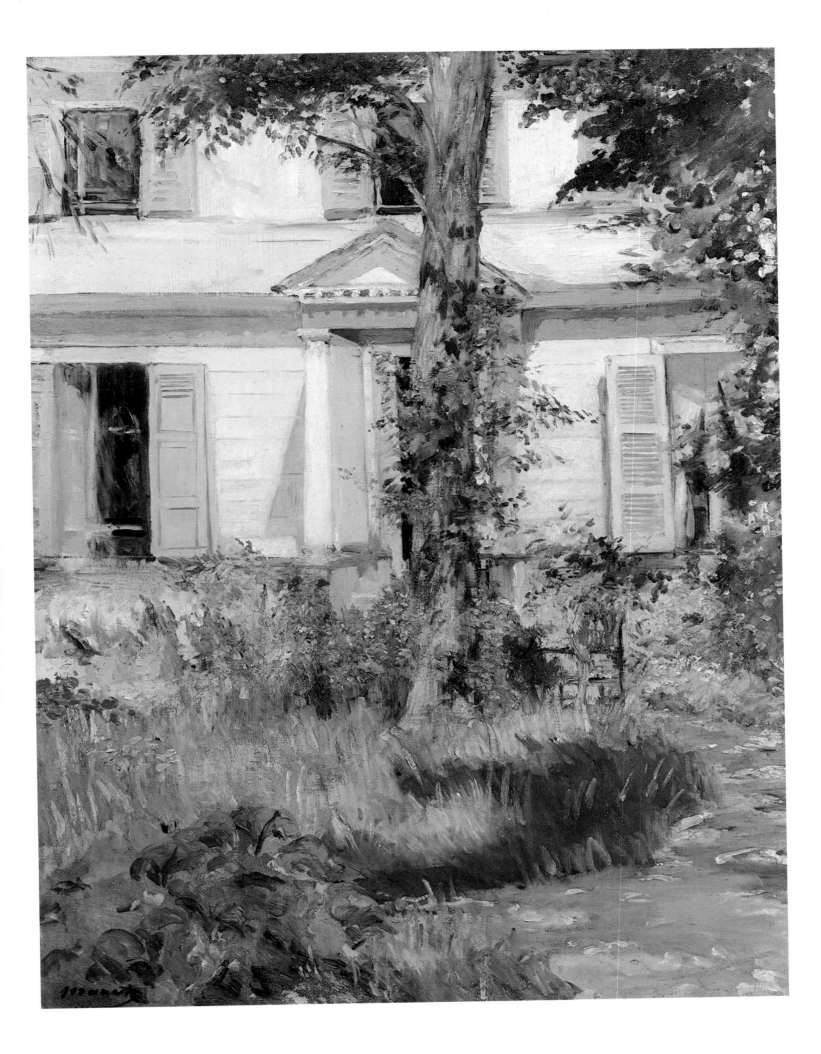

Roses and Tulips in a Vase

c.1882. Oil on canvas, 54 x 33 cm. Foundation E. G. Bührle collection

Manet's studio had always contained flowers, but never so many as during the last year of his life. Friends, acquaintances, even people he had never met, sent him flowers, since it was known that their presence gave him pleasure. Méry Laurent sent her maid Eliza with a bunch of flowers every day.

This arrangement of roses and tulips was painted in the last few months of Manet's life. It is a simple arrangement, set against a plain background. Jacques-Emile Blanche said that he recalled Manet painting still lifes 'in the dry, cold light of a high bay window with a northern exposure.' 'It was towards the end of his life, coming unexpectedly upon him seated before his easel, that I was occasionally enabled to note what a scrupulous and conscientious draughtsman he was, ever ruled by nature . . .', Blanche wrote, 'And how, often and often, he corrected the shape of plates, of crystal vases, measuring, using a plummet, just like a schoolboy!'

Manet died in April 1883. Berthe Morisot wrote:

'These last days were very painful; poor Edouard suffered atrociously . . . The expressions of sympathy have been intense and universal; his richly endowed nature compelled everyone's friendship; he also had an intellectual charm, a warmth, something indefinable, so that, on the day of his funeral, all the people who came to attend – and who usually are so indifferent on such occasions – seemed to me like one big family mourning one of their own.'

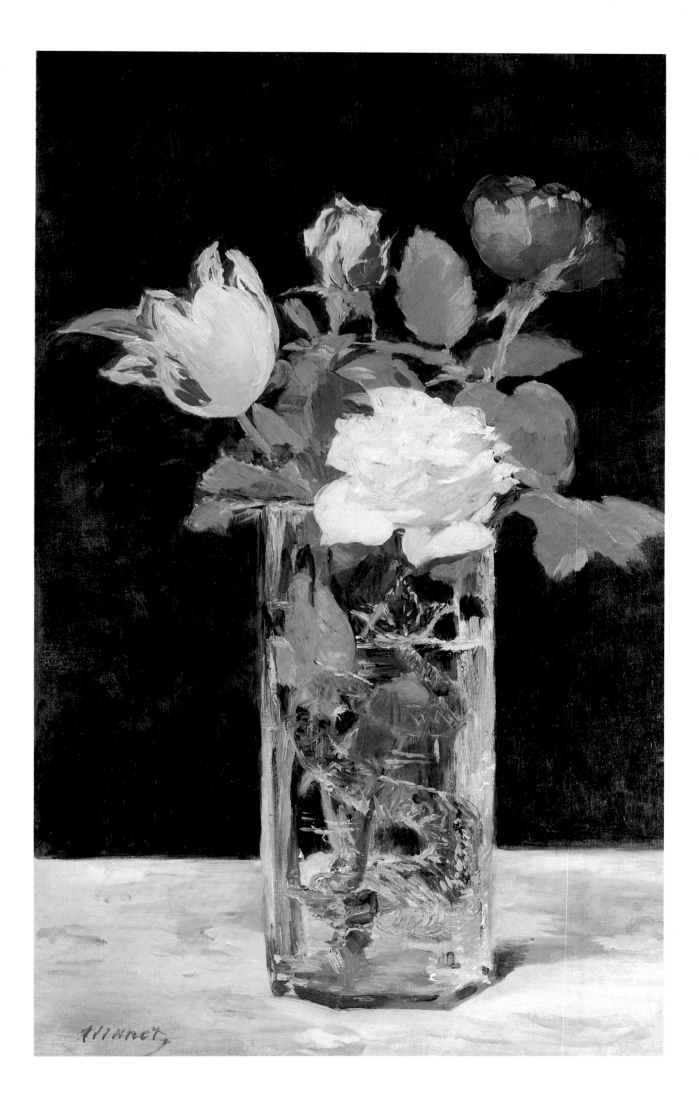

PHAIDON COLOUR LIBRARY
Titles in the series

FRA ANGELICO
Christopher Lloyd

BONNARD
Julian Bell

BRUEGEL
Keith Roberts

CANALETTO
Christopher Baker

CARAVAGGIO
Timothy
Wilson-Smith

CEZANNE
Catherine Dean

CHAGALL
Gill Polonsky

CHARDIN
Gabriel Naughton

CONSTABLE
John Sunderland

CUBISM
Philip Cooper

DALÍ
Christopher Masters

DEGAS
Keith Roberts

DÜRER
Martin Bailey

DUTCH PAINTING
Christopher Brown

ERNST
Ian Turpin

GAINSBOROUGH
Nicola Kalinsky

GAUGUIN
Alan Bowness

GOYA
Enriqueta Harris

HOLBEIN
Helen Langdon

IMPRESSIONISM
Mark Powell-Jones

**ITALIAN
RENAISSANCE
PAINTING**
Sara Elliott

**JAPANESE
COLOUR PRINTS**
J. Hillier

KLEE
Douglas Hall

KLIMT
Catherine Dean

MAGRITTE
Richard Calvocoressi

MANET
John Richardson

MATISSE
Nicholas Watkins

MODIGLIANI
Douglas Hall

MONET
John House

MUNCH
John Boulton Smith

PICASSO
Roland Penrose

PISSARRO
Christopher Lloyd

POP ART
Jamie James

**THE PRE-
RAPHAELITES**
Andrea Rose

REMBRANDT
Michael Kitson

RENOIR
William Gaunt

ROSSETTI
David Rodgers

SCHIELE
Christopher Short

SISLEY
Richard Shone

**SURREALIST
PAINTING**
Simon Wilson

**TOULOUSE-
LAUTREC**
Edward Lucie-Smith

TURNER
William Gaunt

VAN GOGH
Wilhelm Uhde

VERMEER
Martin Bailey

WHISTLER
Frances Spalding